RODIN

AND THE

DANCE

OF

SHIVA

Edited by

Katia Légeret-Manochhaya

UNIVERSITÉ
PARIS8
VINCENNES-SAINT-DENIS

NIYOGI
BOOKS

Supported by

UNIVERSITÉ
PARIS8
VINCENNES-SAINT-DENIS

Université Paris 8, 2 Rue de la Liberté, 93526 Saint-Denis, France

Published by

NIYOGI BOOKS

D-78, Okhla Industrial Area, Phase-I
New Delhi-110 020, INDIA
Tel: 91-11-26816301, 49327000
Fax: 91-11-26810483, 26813830
email: niyogibooks@gmail.com
website: www.niyogibooksindia.com

Text © Katia Légeret-Manochhaya, for individual essays with the author
Photographs © As credited

Editor: Upama Biswas
Design: Shashi Bhushan Prasad

ISBN: 978-93-85285-15-8
Publication: 2016

Printed at: Niyogi Offset Pvt. Ltd., New Delhi, India

CONTENTS

INTRODUCTION

KATIA LÉGERET-MANOCHHAYA

In 1911, at the height of his fame, Auguste Rodin received 27 photographs of bronze sculptures, images taken in southern India at the Government Museum in Chennai. The sculptures represented Shiva[1], god of dance, embodying the Naṭarāja, "King of Dancers and Actors". These snapshots came from Russian archaeologist Victor Goloubeff[2], director of the Paris-based review *Ars Asiatica*[3]. He requested that Rodin write a text about the bronzes. Rodin subsequently wrote a few pages in the form of poetic fragments—"The Dance of Shiva". But these writings remained unpublished until four years after his death, when they appeared in the third issue of *Ars Asiatica* in 1921. However, it would be many more years before the French readers would truly discover these writings, virtually ignored despite their status as one of Rodin's rare texts on the subject of dance. A later republishing of these texts in 1998 was quite understated, unaccompanied even by the photographs of the Shiva sculptures.[4]

The uniqueness of these writings is rooted in the fact that they explore two art forms virtually unknown to Rodin, as he had never viewed these Indian sculptures in person, nor had he seen the live dances that they have evoked to Hindus over the centuries. This dance posture of the god Shiva is an integral part of the traditional repertoires of Indian actor-dancers,

with 108 different variations (the karaṇa), particularly in pieces, depicting cosmogonic myths. Rodin would never have been able to see these works, given that the first traditional-style performance by an Indian troupe in Paris did not take place until 1938—a work of *bharatanāṭyam* under the direction of the famous dancer Ram Gopal.

How could a sculptor of such renown become a poet describing in his poetry a dance form heretofore unknown to him? And why did he place such importance at the end of his life on this particular connection between dance, sculpture, and poetry?

As he cultivated his interest in dance, Rodin had the opportunity in Paris to discover two styles from the Far East, both deeply inspired by Indian dance-theatre: that of the Javanese dancers at the 1889 World's Fair, followed by that of the Cambodian dancers at the 1906 Colonial Exhibition in Marseille[5]. The Javanese performers were official dancers from the heart of their nation, performing the repertoire of the Sultan of Solo's own ballet corps. Rodin sketched them very little. By contrast, he made 150 drawings of the Cambodian performers from the royal court of Sisowath, stating, "They are beyond the beauty that we or that I, can grasp."[6] In addition to his exposure to these authentic performances, Rodin later developed a certain "exotic" concept of Indian dance via his relationship with the dancer Dourga, known in Paris as "The Hindu". In the world of French music halls, Dourga was a rarity: a dancer from the Far East with quite a dazzling career.

What connections did Rodin weave among these so-called "exotic" dances, Indian sculpture, and his own sculpture? In what ways does the Indian concept of a cosmic dance, incarnated by the actor-dancer[7], approach Rodin's artistic concepts of life—"this thing that penetrates you in every sense"—and of nature—"a perpetual ravishing, a boundless intoxication"[8]?

His poetic vision is based upon the photographs of sculpted gods, rather than upon the presence of live dancers. The art of photography is necessarily limited; in a fortieth of a second, it isolates and freezes a single pose from a full movement, rather than revealing or suggesting (like Rodin's sculptures) the potential next movements in space. Rodin

showed, for example, how snapshots of his *Saint John the Baptist* (1878) suggest a man hopping on one leg, while what he had sculpted was the continued movement of a stride, the "movement as a transition from one bearing to another", an imperceptible shift between "one part of what was" and the partial discovery of "what is going to be."[9] Consequently, how can one analyse the dancing body of the god Shiva based on simple photographic reproductions?

A key to interpretation is found in Rodin's text on Shiva, as he compares a movement captured in the Shiva bronze with one of his Venus of Medici, a copy of which he had in his studio. Rather than directly establishing a connection between the two antique statues, he mentions the method of observation that he renews each time he seeks inspiration. In Rodin's interviews with Paul Gsell, he explains that if one passes a beam of light from an electric lamp over the details of a sculpted human figure, the mineral seems to transform into a near-living flesh, making the shapes surge as if they were "projections of inner volumes." Thanks to this "prodigious symphony in black and white," Rodin evokes a dancing movement by holding the light source. This shows "sections so finely shaded that they seem to dissolve in the air." The dance seems to become inherent to the sculpture, defined by an arrangement of several types of movement: the body, the materials, and the micromovements. It also includes the perception of a spectator-actor who participates in the "performance" via the mobility of his own exterior gaze and by the type of lighting he selects. Might Rodin have been thinking of Loïe Fuller, one of the great dancers he often saw? Beginning in 1892, Fuller invented a scenography in which electric lighting became an essential aesthetic element, illuminating the whirling movements of the dozens of meters of white fabric she wore on Parisian stages. Technicians were placed at various locations in the theatre; each held a spotlight in the left hand and turned a glass disk of various colors with the right hand. As they all directed their lights upon Fuller, her image was multiplied ad infinitum.[10]

We can also see how "The Dance of Shiva" hints at a staging invented by Rodin, as if the bronze became a model, not to replicate another sculpture but rather to be set into motion in a work of poetry. The

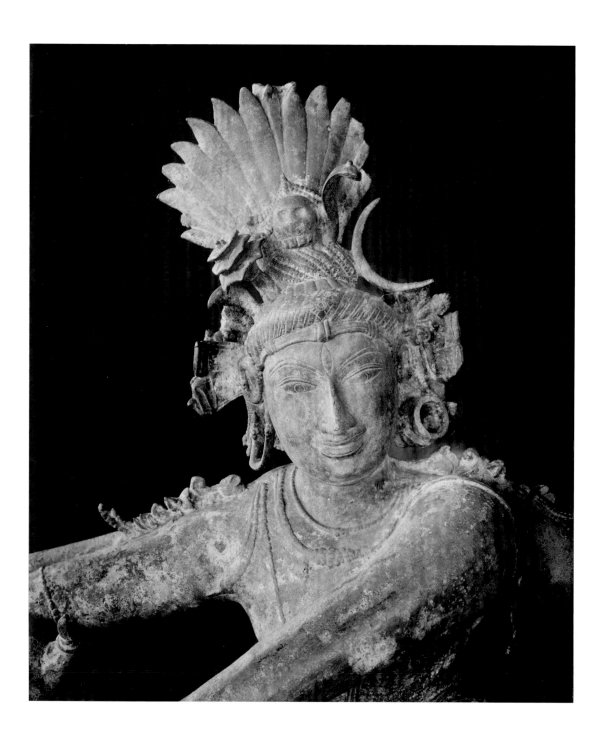

reader gets caught up in it, as the mobility evoked by the sculptor's words erases the frozen vision of so many images of this cosmic dance god. Rodin goes so far as to forget the series of photographs that divide up the body, concentrating on a food, a hand, or a facial detail. Rodin himself enjoyed mixing the profiles of these Indian statues in his descriptions. To compensate for the double immobility of a posture in both bronze and on paper, Rodin elaborated in his writing upon an original poetic conception of rhythm, seeing in this sculpted body a precious instant in which multiple forces confront each other. Shiva becomes the model of this. In addition, in a number of Rodin's drawings we will see dance positions analogous to those of the *Nāṭyaśāstra*, the ancient Indian treatise on theatre and dance, as listed in its *karaṇa*, poses which later inspired the dances of Cambodia and Java.[11]

The research laboratory on "Knowledge and the Stage" at Université Paris 8 includes a group of young researchers and artists trained in the Indian classical dance forms of *kūṭiyāṭṭam*, *bharatanāṭyam* and *odissi*. In this book, this group presents a study of "The Dance of Shiva", transposing Rodin's poetic prose into the non-verbal language of their respective styles of dance. Following a performing arts renaissance inseparable from the complex phenomenon of transculturation, why should this writing of Rodin's attract attention a century later? What are the aesthetic, linguistic, political and transcultural considerations of its translation into several Indian languages and of its adaptation for the stage in France and India?

How is Rodin's text received by contemporary artists, researchers and audiences, both French and Indian? Indian actor-dancers communicate a text by transposing it into learned gestures (*mudrā* et *hasta*) that alternate rhythmic movements with sculptural poses; how does this non-verbal language contribute to an understanding of Rodin's text? Do the inter-and intra-semiotic experiments within such poetic and artistic translations of "The Dance of Shiva" propose a particular form of resistance to a dominant language or ethnocentric model? Can they contribute to the enrichment or transformation of certain elements of codified language unique to the contemporary Indian artist, to the extent that certain words

FACING PAGE: Photograph of one of the two Shiva bronzes that inspired Rodin's text

chosen by Rodin to describe Shiva are practically untranslatable? Can we discuss (speak about) the current interfaces among the artistic categories— sculpture, poetry, dance, theatre, music, photography, and architecture— suggested by Rodin's text? Given the particular importance that he placed at the end of his life on the relationships among the different arts, we will be able to see how poetic writing permitted him to connect sculpture and dance in such a way—never does one illustrate, nor obscure, nor risk to erase the other.

Rodin sought to comprehend the inherent meaning of the rhythmic interplay among moments of equilibrium, disequilibrium and tension characterising this dance posture of Shiva's, without getting caught up in symbolic and mythological ornaments. Does this resonate with some of his own pieces when he draws or sculpts successions of acrobatic forms, suggesting their incompleteness or disappearance? What does this text teach us about the manner in which Rodin cultivated the memory of Antiquity and the desire for an original, ephemeral event? In this unprecedented meeting between ancient sculpture and Indian dance, and their eventual staging in poetry, Rodin invites us as contemporary readers to see his own body of work anew, and to regard these distinct arts differently. In his text, he shows us a unique alliance between interpretation and invention, between the reconstruction of the past and the arrangement of new forms.

The full Rodin text follows this introduction; this represents its second publishing in English, following a first in 1998. As we seek to understand the sources of Rodin's inspiration, we add an Indian perspective on the sculpted image of Shiva that Rodin had contemplated: that of H.S. Shiva Prakash, poet, playwright, and professor of aesthetics at Jawaharlal Nehru University, New Delhi.

Bénédicte Garnier, scientific manager for Rodin's collection of antiques, explains Rodin's passion for another genre of antique sculptures influenced by India: those of Southeast Asia. Rodin discovered the art of Cambodia and Indonesia at the 1900 Universal Exposition in the Dutch East Indies pavilion, which displayed castings from the Borobudur temple sculptures.

This volume represents the proceedings of the one-day conference on 17 October 2012 at the Musée Rodin in Paris, co-organised by Université Paris 8 (Research Laboratory EA 1573—The Stage and Knowledge) and the museum. It incorporates several elements of the original work "Shiva-Rodin", a staging of the text of Auguste Rodin's "The Dance of Shiva", produced by Katia Légeret-Manochhaya and presented a few days following the conference at the Parisian theatre La Reine Blanche.

Endnotes

1. In Sanskrit, the first letter of the word Shiva is written with an "s" with a diacritic above, and the pronunciation is similar to "sh" in English and "ch" in French. The French transcription of this sound is either "ç" or more commonly "sh". Rodin and the *Ars Asiatica III* review used the "ç". In this edition in english, the title is Rodin and The Dance of Shiva. In the text, in view of cohesion with this title, the word Shiva is kept as in the title, and it is the only sanskrit word without diacritics.

2. After participating in an exploration of the Ajanta caves in India, Victor Goloubeff went on to become a member of the French School of Asian Studies [EFEO - Ecole Française d'Extrême-Orient] after gaining French nationality. He got on well with Rodin, who made a marble bust of Mrs Goloubeff between 1905 and 1906.

3. *Ars Asiatica III, Etudes et documents publiés sous la direction de Victor Goloubeff, Sculptures çivaïtes par Auguste Rodin, Ananda Coomaraswamy, E.B Hawell et V. Goloubeff.* [*Ars Asiatica III, Studies and documents published under the direction of Victor Goloubeff, Shivaist sculptures by Auguste Rodin, Ananda Coomaraswamy, E.B Hawell and V. Goloubeff*], Brussels and Paris, National Bookstore of Art and History [Librairie National d'art et d'histoire] G. Van Oest and Company, 1921. In the Foreword, Victor Goloubeff explains that the review will henceforth be published with the support of the EFEO, whose editorial department is headquartered at the Musée Guimet. He indicates that Calude Maître, director of the school, was responsible during Goloubeff's absence "for reading the proofs and overseeing the printing of the volume." This third volume was printed in heliotrope by Léon Marotte in Paris, and in 15 high-end copies with the text and printed plates on Imperial Japanese paper. On the brown cardboard cover, the title is printed in golden letters, along with a simplified drawing of the bronze sculpture of the god Shiva Naṭarāja. Other than the copy kept at the Musée Rodin, three other copies exist in Paris, at the Musée Guimet, at the central library of the Louvre, and at the library of the Musée d'Orsay (inventory number 14330). The photography library of the Musée Guimet has 33 24x30 negatives of the Shiva Naṭarāja bronzes, which were sold to the Maison Van Oest and then repurchased

by the Musée Guimet between 1920 and 1934. While documentation on this subject is lacking, it seems likely that Victor Goloubeff was the photographer of these bronzes and of those in the March 1921 *Ars Asiatica* review. The significant number of large-format shots, which Goloubeff took of the principal archeological sites of India and Java and then deposited at the Musée Guimet, constituted the first consistent collection of that museum's photographic archives.

4. This text was republished for the first time in 1998 in a publication including other writings by the same author: Auguste Rodin, *Eclairs de pensée, écrits et entretiens* [*Flashes of Thought, Writings and Interviews*] (Paris: Editions Olbia, 1998), pp. 73–79. However, the photographs that had inspired Rodin's text and that were published in *Ars Asiatica III* were not reprinted in the 1998 publication, nor in its December 2008 reprinting by Sandre publishing.

For a Royal Academy exhibition of the bronzes of the Chola dynasty in London, 11 November 2006–25 February 2007, the exposition catalogue published the Shiva Naṭarāja photograph by Velangani that was included in *Ars Asiatica III* along with an English translation of Rodin's "The Dance of Shiva".

5. *Rodin et les danseuses cambodgiennes* [*Rodin and the Cambodian Dancers*] (Musée Rodin, 2006), p. 61. This collective work was published on the occasion of the exposition "Rodin and the Cambodian Dancers. His last passion" which took place at the Musée Rodin from 16 June to 17 September, 2006. The exhibition curator was Jacquest Vilain, chief heritage curator.

6. Letter to Rainer Maria Rilke, 8 November 1907, in *Correspondance de Rodin*, published by Musée Rodin.

7. "The movement of whose body is the world, whose speech the sum of all language, Whose jewels are the moon and stars — to that pure Shiva I bow" This poem, which all Indian actor-dancers learn by heart, dates back to before the sixth century and is taken from the *Abhinaya Darpana* by Nandikeshvara. The first English translation of this work was undertaken by Ananda Coomaraswamy and published in 1917 as *The Mirror of Gesture*, by Harvard University Press, Cambridge.

8. Auguste Rodin, *Eclairs de pensée, écrits et entretiens* [*Flashes of Thought, Writings and Interviews*] (Paris: Editions Olbia, 1998), p. 57 and Auguste Rodin, *L'art, Entretiens réunis par Paul Gsell* [*Art, Interviews Assembled by Paul Gsell*], Les Cahiers Rouges collection (Paris: Editions Grasset, 1911), p. 41.

9. Auguste Rodin, *L'art, Entretiens réunis par Paul Gsell* [*Art, Interviews Assembled by Paul Gsell*] (Paris: Editions Grasset, 1911), pp. 57–58 and later pp. 50–51. Despite this critique of his theory, Rodin was an innovator among sculptors in his varied usages of photography: as model for creating engravings, drawings, or documentation sketches, or even as a memory aid for correcting a sculpture. In the majority of photographs taken by Eugène Druet, Rodin included his own signature next to that of the photographer, as the sculptor had actively participated in determining the shots of his work. He asked Jacques-Ernest Bulloz to photograph his sculptures from many

angles so that the spectator would have the impression of walking around the sculpture at close proximity. For more on this subject, see Hélène Pinet's *Rodin sculpteur et les photographes de son temps* [*Rodin: the Sculptor in the Light of his Photographers*] (Paris: Editions P. Sers, 1985).

10. Giovanni Lista, *Loïe Fuller, danseuse de la Belle Epoque* [*Loïe Fuller, Dancer of La Belle Epoque*] (Paris, 1994), pp.154–160. The human form is faded out by the veils surrounding this luminous body while the organic and physical dimensions are transcended in a dreamlike visual experience, as the public sees flowers, flames, or butterflies in succession. As opposed to Rodin, who never managed to sculpt this artist also admired by painter Henri de Toulouse-Lautrec and by the poet Mallarmé, Pierre Roche created several works based upon Fuller starting in 1894, including a large statue in 1900 for the Loïe Fuller Theatre, constructed by Henri Sauvage for the World's Fair in Paris.

11. In Cambodia, in the Shivaist temples of the tenth and twelfth centuries, the dancing poets of Shiva were sculpted, for example, upon the pediments of Vat Ek and Vat Baset. The Javanese tradition also included this Indian vocabulary. See Alessandra Iyer, "Nrittakaraṇa-s in ancient Java," in *Théâtres indiens* (Paris: EHESS, 1998), pp. 137–153.

Translated from the French by Jennifer Post Tyler

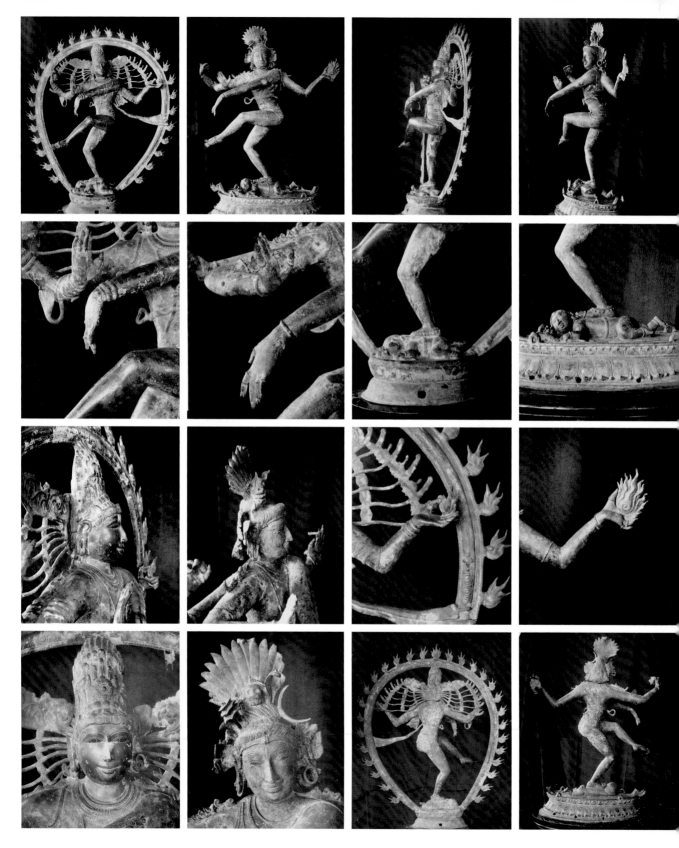

THE DANCE OF SHIVA: RODIN'S FULL TEXT

Viewing the full Shiva:

In the full bloom of life, the flow of life, the air, the sun, the sense of being simply overflows. This is how the art of the Far East appears to us!

The divine nature of the human body was obtained at that time, not because we were nearer to our origins - for our forms have remained stable - but rather that we believed in freeing ourselves from the servitude of the present, and we flew off into the heavens. It is a pleasure sincerely missed...

From a certain angle, Shiva is a slender crescent.

What talent, what pride in the body!

Today, it is a perpetual beauty in the bronze. The imperceptible movement of the light. One senses these motionless muscles, under rays of light, ready to burst into movement should the light shift...

FACING PAGE: Photographic snapshots of the two Shiva Naṭarāja bronzes, images given to Rodin by Goloubeff

The shadows move closer and closer, engulfing the work of art and lending it the charm of the deathly grace of darkness, that place where it has lingered so long…

These hints of perfection! The mist of the body! As if divinely ordained, there is no intimation of revolt in this body: one feels that everything is in its place. We see the rotation of the arm even at rest by examining the shoulder blade, how it protrudes, the rib cage, the admirable attachment of the ribs holding the shoulder blade in place, ready to move. And the side that continues this torso: narrow here, tight there, and then widening to articulate two thighs, two rods, two levers, with perfect angles, delicate legs that play upon the ground…

Viewing a profile of Shiva:

Admirable, these two hands that separate the breasts and the stomach. This posture could rival the grace of the Venus of Medici; as she shields her physical beauty with her arms, so appears Shiva, seeming to protect himself with this ingenious movement.

This right shadow that separates the torso into two parts, gliding down the length of the thighs, one in chiaroscuro, the other entirely in obscurity. The pubis cannot be seen, concealed in this obscurity…

In sum, it is the virtues of depth, of opposition, of lightness, and of power that matter; but these details are useless in and of themselves, worthless embellishments except in relation to movement…

These legs with their elongated muscles contain only speed.

The thighs, so close together, a double caress, jealously enclosing the shadowy mystery; the beautiful field of shadow rendered more evident by the light upon the thighs.

Facing Shiva:

The posture is known among artists, but at the same time, it is uncommon; for in every pose there is nature, and such distance! There is indeed what some people do not see: the unknown depths, the depth of life. In elegance, there is grace, and based upon grace, there is the ideal; everything goes further. We say it is gentle, but it is powerfully gentle! Thus words fail us…

There are garlands of shadows stretching from the shoulder to the hip, from the hipbone to the thigh at right angles…

From another profile of Shiva:

These two legs in differing lighting; each thigh casts a shadow upon the other leg.

If there were no interior model, the contour could never be so fluid and supple. It would be too dry with this direct shadow.

On the supposedly barbaric art of Shiva:

The ignorant man simplifies and crudely observes; he strips away the life of a superior art for love of something inferior, and ultimately realizes nothing. One must study further in order to take deeper interest and to see…

On contemplating the head of Shiva at length:

This swollen mouth, so prominent, abundant in its sensual expressions…

The tenderness of the mouth and the eyes are in harmony.

These lips are like a lake of pleasure, bordering the nostrils which quiver in their nobility.

The mouth undulates in delicious moisture, sinuous like a snake; the closed eyes are enlarged, closed amidst a confection of lashes.

The wings of the nose are drawn tenderly upon the background of the full face.

The lips that create words, moving as they escape: such a delicious serpent in motion!

The eyes that have but one place to hide are made of the purity of line, of the tranquility of nestled stars. The fair tranquility of these eyes; a tranquil drawing; the tranquil joy of this calm.

These curves converge and stop at the chin.

The expression continues with one ending that turns back into another. The motions of the mouth are lost in the cheeks.

The curve coming from the ear traces a small curve that pulls at the mouth and a bit at the wings of the nose; it is a circle that passes under the nose and chin, up to the cheekbones.

The raised cheeks turn in.

Still before the eloquent head of Shiva:

This eye remains in the same place as its companion, in an opportune shelter; it is voluptuous and luminous.

The closed eyes, the contentment of time passing.

These eyes are drawn precisely, like a precious enamel.

The eyes set in the jewelry box of the eyelids; the arch of the lashes, and that of the generous lip.

Mouth, lair of the sweetest thoughts, but also a volcano of rage.

The materiality of the soul that could be held captive in this bronze for several centuries; desires of eternity on these lips; the eyes that will see and speak.

Eternally, life enters and leaves via the mouth, like bees' continual comings and goings; sweet, perfumed respiration.

This lovely lost profile indeed has its own profile, but where expression draws to a close and sinks deep, leaving the charm of cheeks curving down to join with the cords of the neck.

Translated from the French by Jennifer Post Tyler

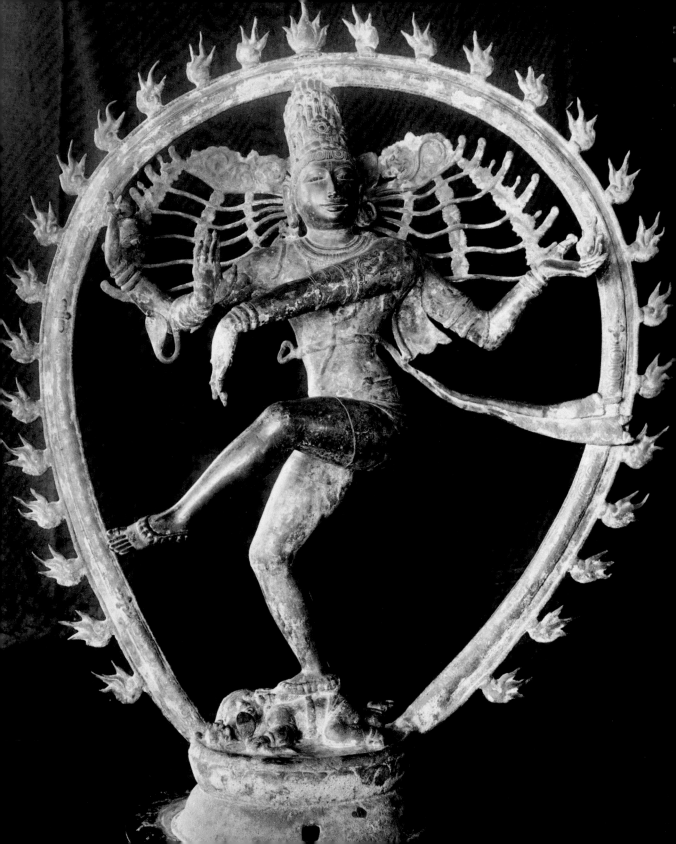

THE DANCE OF SHIVA: SOURCES OF INSPIRATION FOR RODIN'S TEXT

KATIA LÉGERET-MANOCHHAYA

R odin took inspiration from multiple sources to write "The Dance of Shiva": the photographs of two Indian bronzes of Shiva Naṭarāja (fig. 1 and 2), the so-called "exotic" dancers that he frequented in Paris, the relationships between his 1910 sculptures named *Dance Movements* and certain drawings of his, including two of Cambodian dancers, certain Venuses in his collection of antiques, some teakwood Indian sculptures purchased in 1914, and fragments of texts occasionally scrawled in haste in his small notebooks and gathered in his book *The Cathedrals of France*, published in 1914. Research in the Musée Rodin archives has revealed that the divine dancer that Rodin

FACING PAGE (FIG. 1): Photograph of full front profile of Shiva Naṭarāja with a ring of flame encircling it, that Rodin received from Goloubeff

imagined himself walking around, as he did with his living models, was seen as being at once both feminine and masculine. What is this feminine model, then, that he envisions in the Shiva Naṭarāja , indeed surpassing the comparison with the Venus of Medici?

PHOTOGRAPHS OF THE SHIVA NAṬARĀJA BRONZES

Rodin's personal collection

In the archives of the Musée Rodin in Paris, we find 25 photographs of the two Shiva Nātaraja bronzes then displayed at the Government Museum in Chennai. However, only 12 of these photographs were selected by *Ars Asiatica*[1] to accompany Rodin's text in the 1921 publication. Six correspond to the first bronze of the dancing god. In the publication's introduction[2], Victor Goloubeff explains that the 1.15m bronze dates from the tenth century and was found in 1872 by Velangani in the south Indian Thanjavur district.

The second bronze, which corresponds in the *Ars Asiatica* review to six subsequent plates, is likely the older of the two, and the ring of flames that originally encircled it is now broken. The two bronzes are currently on view at the Government Museum in Chennai under a glass case (Cf. postface). Protected by the glass enclosure from oxidation, the bronze material seems to have escaped the vicissitudes of time. The Indian aesthetic cultivates this importance of the radiance and shine of these divine figures, as is evidenced by the careful maintenance of temple statues, which are regularly bathed in oils, water, milk, and perfumes. In contrast, a careful examination of the thousand-year-old Shiva Naṭarāja exhibited at the Musée Guimet in Paris reveals a clearly visible natural patina that colours the statue with marks of verdigris due to the oxidation of the copper.

The *Ars Asiatica* review

After six years of hiatus, the *Ars Asiatica* review relaunched in 1914 under the new direction of Victor Goloubeff. Numerous were the articles that he requested from friends at that time, but that were published much later. This was the case in 1921 with Rodin's text, "The Dance of Shiva". In the

FACING PAGE (FIG. 2): Shiva Naṭarāja from Thanjavur, image given to Rodin by Goloubeff

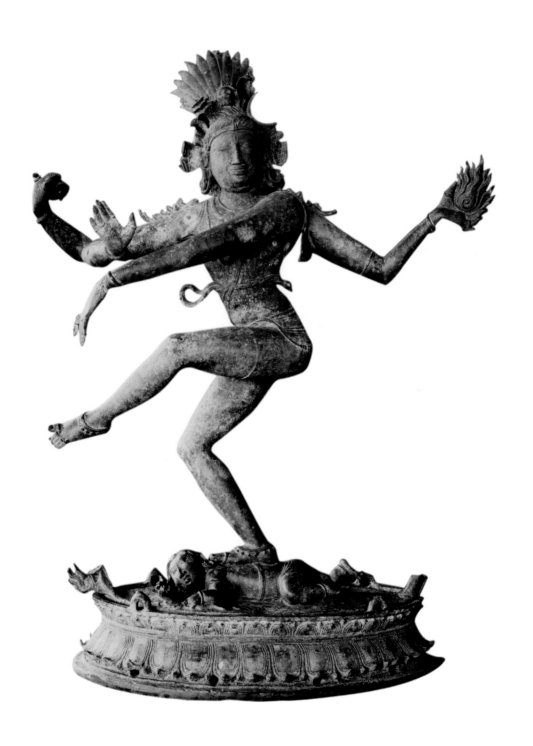

"Foreword" of *Ars Asiatica III*, written in Angkor in 1920 and published in 1921, Victor Goloubeff explains the goal of advancing "an artistic and knowledgeable France in its relations with Asia." He mentions that the photographs published in the review were taken in 1911, during one of his Indian voyages, and that he himself had brought them to France and deposited them with the Musée Guimet in Paris. Goloubeff goes on to state that Rodin had written his text in the autumn of 1913, while Rodin was in the midst of preparing his book on the cathedrals of France. During several of Goloubeff's interviews with the sculptor, Rodin would mention "some analogies between Indian art and the art of the Middle Ages."[3]

From the numerous letters exchanged between Rodin and the Goloubeffs, we know that the sculptor had often been invited to tea at the Goloubeff's Parisian home or to stay at their property in Bavaria. Starting in 1905, Madame Goloubeff had begun posing in Rodin's studio for a sculpture of her bust. We can also suppose that Rodin had access to some information about the history and symbolism of these Indian bronzes. Victor Goloubeff had at that time in his possession a private collection of 25 Asian sculptures, miniatures, and reproductions of paintings.[4]

In the "Bibliographic notes" of *Ars Asiatica III*, Victor Goloubeff cites the publications that he knew of regarding Indian art. Only two of them had been published before autumn 1913, when Rodin was writing his text. In 1908, E.B. Havell, prominent scholar of Indian art and architecture (author of a text in *Ars Asiatica III*) had already dedicated several pages to the description of the first bronze of Shiva Naṭarāja photographed in that review and better known under the name Shiva of Velagani.[5] The second was that of Émile Guimet—founder of the Musée Guimet in Paris—describing the temple of Mahabalipuram in "Eight days in the Indies", an excerpt from the book *Tour du Monde*, published in Paris in 1889.[6] During this same period, quite close to Rodin's writing of "The Dance of Shiva", two other important publications were released: *Elements of Hindu Iconography* by T.A Gopinatha Rao (1914) and *South Indian Bronzes* by O.C Ganguly (1915). The latter is considered by Victor Goloubeff as "a study of great scope, well documented…one finds in it some iconographic information that had been missing until now." In *Ars Asiatica III*, the analysis done

of the Shiva bronzes by Ananda Coomaraswamy is erudite but based upon literary texts rather than upon a strictly iconographic interpretation. His undated article, entitled "Instructions on the entity and the names of Shiva (Plates I-XII)", is directly linked with the 12 photographs of the bronzes, like Rodin's text. It gives numerous citations on the attributes and the functions of the god Shiva, taken from ancient and major texts such as the *Linga Purāna* and the *Periya Purānam,* as well as the *Tiruvācagam* of Mānikka Vācagar and the *Mahābhārata.*

Enumerating some of the thousand names for this god, such as "Icvara, Rudra, and Hara," he concludes with the idea—often admitted in India—that Shiva "adopts the form that his adorers imagine." In this sense, the freedom of interpretation evident in the fragments written by Rodin would be one possible vision of the Naṭarāja![7]

Symbolism of the Naṭarāja

Rodin was interested in the best-known form of Shiva, that of Naṭarāja—King of the actor-dancers.[8] This God ceaselessly alternates among his five functions: creation, preservation, destruction, grace, and liberation. In the photographs of the bronzes studied by Rodin, these functions essentially correspond to the position of the feet and the hands. First, the principle of creation with the top right hand holding the drum: the creative sounds that it produces correspond to the phonemes of the Sanskrit language. Actor-dancers still honor this tradition onstage today, synchronising their steps with the rhythmic syllables, chanted with force or sung with vigor and accompanied by a percussionist.[9] The right hand in *abhaya* carries out the function of

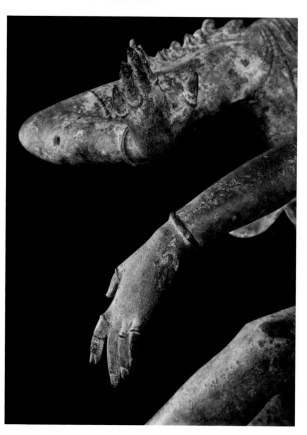

(Fig. 3): The protective hand of Shiva Naṭarāja

divine protection, dispelling fear. (Fig. 3) While destruction of ignorance and illusion is ensured by the right foot, which crushes the demon dwarf *apasmāra*, and by the upper left hand, which holds the flame. (Fig. 4) Grace is manifested by the lower left hand in *varada*, granting benefits. (Refer fig. 3) Finally, liberation from all earthly attachments is suggested by the elevation of the left foot, at which the fingers of the lower left hand are pointed—*gaja hasta* or *ḍola hasta*.

Shiva holds himself in balance at the center of this circle of flames, rendering this dance a dazzling act renewed by creation and its destruction. The text of the *Īśvara Gītā* describes it in these terms:

> The ascetics threw out the one who, dominating the full universe, covered it with his splendor; he, the god of frightening fangs, the terrifying god, whose splendor is equal to that of ten million suns. They threw out the one who was dancing, emitting a flame of fire and setting alight the entire world; him, the god creator of all, the Lord.[10]

(FIG. 4): Shiva's hand holding the flame

The *alātācakra* symbolises the multiplication of earthly forms manifested, subject to perpetual transformation. From a human point of view, this circle is reminiscent of the circumambulation performed by pilgrims around the holiness of the temple. Certainly, the Hindu symbolism of this circle did not figure in Rodin's attention. But it is, however, exactly the way that he composed a work—by walking around his model: each moment, stopping to contemplate the model from a particular profile, which was then transformed by the following

one. As he explained in an interview with Henri Dujardin-Beaumetz[11]: "I proceed methodically by studying the profiles of the model I am copying." He adds that this was the method for creating the "statues of Antiquity: but it has indeed been forgotten today." He cites a writing by Goethe that inspires him: "If in the infinite you want to stride, just walk in the finite to every side." Rodin goes on in this text to consider rotation as fundamental to all human displacements:

> The human body is a temple that walks, and as a temple, it has a central point around which its volumes are placed and from which they spread. It is a moving architecture.

To write his text, "The Dance of Shiva", Rodin studied the multiple photographs of the God as essential profiles—but the ones that he had not chosen—and he sculpted the material of the French language, while he turned about this model in image and in thought, a model whose original he never knew, as he had never seen these bronzes in reality.

Two other attributes are present in the bronzes pictured in *Ars Asiatica III*: the serpents, wrapped around an arm and lodged in its cuff, as well as a human skull, posed atop the diadem. This figure of the serpent is mentioned in a major text of the fourteenth century, *Cidambaram Māhātamyam,* which recounts one of the foundational myths about this figure of the dancing God. Having learned of the existence of heretic priests living in the forests, the God transforms himself into a nude ascetic, his body covered in ash, and he seduces their wives. Furious, using the magic of their rituals, the rebels call forth three demon forms from the sacrificial fire: a tiger, a snake, and a ferocious dwarf armed with a club. Shiva kills the tiger, wrapping its kidneys with its own skin; he then decorates his body with the snake, and dances on the back of the demon dwarf *apasmāra*[12], showing the triumph of knowledge over ignorance. He raises his left foot, showing the liberation from illusion (*māyā*) and begins *ānanda tāṇḍava*, his dance of blessing. Henceforth the hermits become his devotees. This famous pose, showing a triple destructive action, is thus inseparable from the dance at Tillai, a mythical place but also the location of the temple of Chidambaram, in Tamil Nadu.[13]

SHIVA IN THE PARISIAN MILIEU OF SO-CALLED "EXOTIC" DANCES

Rodin sought an alternative to the stereotyped images of exoticism offered in those times by the grand world's fairs beginning at the turn of the century, tied to the ideology of colonialism. And he took care to inform his readers of this when he spoke of "the supposedly barbaric art of Shiva." At that time, in the Hindu numbers in the music halls, Shiva was indeed the most commonly portrayed divinity, though the God was often assimilated into a goddess as the performers on stage played either the role of a priestess officiating a ritual or the role of a goddess.

But who did Rodin spend time with, in this exotic Parisian scene, who could have introduced him to another interpretation of Shiva? When Rodin visited the 1900 World's Fair, it was in the Far East section that he noted "the most vivid impressions."[14] He discovered there "a marvelous

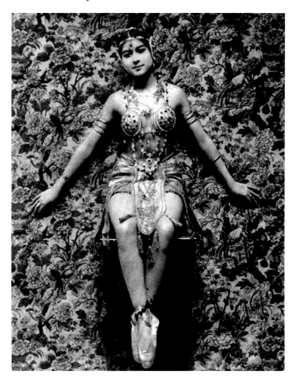

(FIG. 5): The dancer Dourga

art, unknown until now," including "exotic dances". He describes having particularly appreciated "Loïe Fuller, and with her, this Sada Yacco, with such vibrant artistry of prodigious perfection." The dancer Dourga was also a part of this "exotic" Parisian scene. Correspondence between Rodin and Dourga between 1910 and 1916 leads us to believe that she posed for him. (Fig. 5) When he wrote "The Dance of Shiva", she had just turned fourteen and had taken her first steps at the Moulin Rouge, playing the role of a Hindu goddess evolving in the midst of several Buddhas. She later invited Rodin to the Parisian theatre Maison de L'oeuvre, performing dances from Cambodia to music by Bourgault-Ducoudray, as well as Arab and Hindu dances to excerpts of Grieg. She dedicated the show programee to him, and he carefully saved it, as can be seen today in the Musée Rodin archives. Although the Indian origin of this dancer is far from certain, the success of her Hindu dances was immense. In 1924, in his book *Découvertes sur la danse (Discoveries on Dance),* Fernard Divoire cites a press article from 22 July 1916, written about Dourga's performance as the god Vishnu at the Opéra-Comique, in Delibes' ballet Lakmé: "Surprised to the point of enthusiasm, the public was enchanted by this precocious science of Far East rhythms." In 1915, Dourga sent Auguste Rodin a photo taken by Campbell Gray in which she posed as a Hindu dancer.[15]

Premiered by the dancer Mata Hari in 1905, the "Hindu number" infiltrated the choreographic repertoires of music halls up until the 1930s. The great majority of European artists who performed it thus invented an Eastern origin and termed themselves "exotic" or "Hindu". Their repertoire often made allusions to the god Shiva. Born in the Netherlands, the dancer Mata Hari was in reality Margaretha MacLeod, wife of a captain in the Dutch colonial army whom she accompanied during his stint in Java. Later, striking out on her own in Paris in 1904, she concocted several stories of her origins, including one about a childhood spent in the temples of Shiva, where she learned to dance from her priestess mother. She began to dance in Parisian salons and appeared officially as a Hindu dancer on 13 March 1905, during a conference on Vedic dances in the Musée Guimet library. Clad in fabrics and jewels

belonging to the well-known collector of Far Eastern art, Émile Guimet, she danced, progressively removing some of her shiny veils. The rotunda was lit by several small red candles and perfumed with incense, and the eight columns were decorated for the occasion with garlands of white flowers.[16] While the Matin noted the mysterious and sacred India, "that of Brahmins and bayaderes," evoked by this artist, the journalist remained prudent and spoke only of the suggestion and not of authentic ritual: "Mata Hari knew how to evoke quite admirably the ceremonies dear to Vishnu, god of nature, to Indra, god of battle, and to Shiva, god of fury."[17] In the months that followed, she was invited to present her Hindu number in numerous high-society salons frequented by Rodin, notably at the home of Henry Rothschild, at the Grand Circle, at the Royal Circle, at the home of the Princess Murat, or in following projections of films by Mr Gaumont. In August 1905, she danced at the Olympia. The programme of the performance describes her "Invocation to Shiva" in this way:

> The trembling woman resolved to beg Shiva, god of destruction, for whom her slaves will dress her and make her seductive. Her path is strewn with gold powder and rose petals. Before the god, Mata Hari offers him flowers, and then to charm him, she dances, asserting her seductive curves. Does Shiva want more? She will know how to divest herself of all these gifts.

In a photograph from the Musée Guimet archives, we note the presence of a statue of the Naṭarāja resting upon a piece of furniture at the far end of the museum library, where Mata Hari danced in 1905. The museum archives still have the photograph of a bronze Shiva from the seventeenth or eighteenth century that resembles in many ways the one from this event of "exotic" dance.[18] It belonged to the Asian art collector C. T. Loo, known for loaning pieces of his collection for cultural events in Paris.[19] Since Rodin often visited the major antique dealers of that era— as evidenced by his 1914 acquisition of wooden Indian sculptures—he may have been able to see, in this context, a veritable Shiva in bronze. We do not know whether he visited the Musée Guimet and its founder,

but Rodin may have been invited to conferences held there by his friend Goloubeff in 1914.

In December 1912, Mata Hari was invited to the University of the Annals of Paris by Paul Olivier, then a music critic at the Matin. The famous master of Indian music Ustad Inayat Khan was there with his orchestra. Born in Bangladesh, this musician belonged to a dynasty of sitar players, a line of artists going back to the court of the sixteenth-century Mughal emperor Akbar. To accompany Paul Olivier's talk on the rites of Asia, Mata Hari performed "Chandra", a new dance in her repertoire which invoked the moon, as well as another of her compositions, "The Princess and the Magic Flower". She was thus the first Westerner to be accompanied by an authentic traditional Indian orchestra! We note that this innovative Parisian event took place at nearly the same time as the creation of India's first full-length silent film by Dada Saheb Phalke in Mumbai. Ustad Inayat Khan was later seen in Satyajit Ray's 1958 film *Jalsaghar* (*The Music Room*), in which Ustad Inayat Khan and his orchestra accompany Roshan Kumari, a Kathak dancer.

At the time that Rodin was writing his text on the Hindu god of dance, the traditional castes of Indian artists were in full decline. Artists no longer held the right to perform in public, according to rules imposed by the English colonial administration. As temple artists and palace artists were removed from their princely or religious protectorates[20], dancers were nicknamed the "nautch"[21] girls and reduced to entertaining the colonists. Knowing this art via only this colonial vision, the so-called "Hindu" dancers in Paris were content to mention in their programme that the sacred temple art they performed was known as the "nautch" style! At that time, they had no means of knowing the battles being waged by such Indian aesthetes as Tagore, based at Visva-Bharati University, Shantinketan, who invited the most important masters of dance to perform there, particularly in the Kathak and Manipuri styles. It would not be until later that Western dancers interested in this art would travel to India and have their first direct contact with artists there: in 1922, the Russian ballet dancer Anna Pavlova, and in 1925, the American modern dancers Ruth Saint-Denis and Ted Shawn.

The diversity of Indian styles slowly began to be known and respected, and called by their respective names. It is surprising to see that Ruth Saint-Denis and Ted Shawn were able to take a number that passed in 1905 Paris for an authentic Indian dance—obscuring the innumerable cultural identities of the art form—and launch it as choreographic premiere in India! The two dancers performed on Indian stages with a programme of their own, "Nautch Dance", before an audience of traditional Indian dancers![22] To return to Mata Hari's 1912 show, including the dance called "Chandra", a remark should be added: because major Indian artistic families typically include both dancers and musicians, it is indeed possible that Ustad Inayat Khan may have shown Mata Hari some steps and movements from Indian dance.

Passing through Paris in 1906, American modern dance pioneer Ruth Saint-Denis rivalled Mata Hari. Saint-Denis also created Hindu dance numbers at the Marigny Theatre, such as "Incense", "The Cobras" (with music by Delibes), and "Radha". Several months earlier, she had triumphed with her latest premiere at the Hudson Theater in New York. To find inspiration, the dancer took care to visit the Hindu community in New York, as well as to consult with Indian specialist Edmond Russel and to observe the religious ceremonial practices in these communities.[23] Incidentally, her costumes and jewels were much more rich, varied, and refined than those of the French exotic dancers at the time, and her body remained fully clothed. During the press conferences she gave in Paris, she went as far as inventing, like Mata Hari, her own priestess mother in a temple in India. She posed bare-chested for August Rodin, who created several sketches of her. In her memoirs, Ruth Saint-Denis recounts the difficulty she experienced during this episode in seeking to maintain "an appropriate distance" between Rodin and herself, in order to fend off his advances. She invited him, however, to London in 1908 on the occasion of her first performance of oriental dances.[24] Her choreographies were inspired by numerous Asian traditions, and she was recognised in her country as the first artist to have performed Hindu and Egyptian dances for a Western audience.[25]

We have already explained how Shiva was the most commonly depicted deity in the Hindu music-hall numbers of this era, and that the God was

frequently integrated into a feminine deity. For example, in August 1906, when the Hindu dancer Radha performed at the Olympia, the text of the first part of her programme, "Delirium of the Senses", describes the god Shiva as a goddess. The story recounts how the people of the "Aryas of the Ganges Valley" came to seek counsel regarding the plagues that had befallen them. To put a stop to the scourges, Shiva invites these men to renounce all sensuality:

> Then the goddess left the meditation, took a blooming lotus flower, in ecstatic poses expressed the renunciation of the senses. Then the spirit of Shiva became matter and the goddess appeared in a primitive attitude, immobile above the altar.[26]

During the same period, the dancer Sahary Djeli became well-known in Europe and in the United States for her extraordinary contortions. She may have posed for Rodin, for a series of drawings of acrobatic postures that occasionally seem to violate the anatomical principles of the human body. In August 1908, she presented a performance at the Moulin Rouge, "The Nautch, mysterious and frightening Hindu dance", with a level of flexibility that surpassed all imagination, according to the press of the time.[27]

At the Casino of Paris in January 1909, she performed before a Buddha statue:

> This sacred dance "the Nautch" is ancient and mysterious, and only the priestesses of the goddess Kali are initiated to it. It can only be executed in a state of religious ecstasy as the movements are supernatural and demand a flexibility so extraordinary that it extends to the skeleton itself.[28]

The press reported that the audience was in fact frightened by this priestess heroine who lost herself twice to the ecstatic dance, first in thinking of her beloved before entering a temple lost in the forest, and later during the ceremony dedicated to the goddess Kālī. The programme affirmed that Sahary was unique in her genre:

> More than a dancer…she is a creator in every sense of the word, apart
> from the extraordinary flexibility that enables her to bend her body like a
> liana vine in any direction.

Finally, another noteworthy example of the "exotic" Parisienne dancers was Adorée Villany, who was charged with gross indecency for dancing nude at the Comédie Royale. She asked Rodin—who seemed to know her—to publicly come to her defence. She sent him a series of photographs of her performances so that he could estimate for himself her concept of the artistic relationship between nudity and her dances.[29] The Hungarian woman took care to explain in her programmes, on one hand, that "the dance of the future requires a bared body" to show "the naked soul," and on the other hand, that she was interested "in the dances of Antiquity to refresh the choreographic art, concerning its form, its color, and its very essence."[30] Indeed, these claims characterised the beginnings of modern dance: consider Isadora Duncan, who was admired by Rodin and close to him,[31] who turned to ancient Greece for inspiration, eschewing the classic costume of a ballerina for light veils that enabled the shape of her body to be revealed. In 1911, the year that Goloubeff gave Rodin the photographs of the Shiva, Rodin indicated that he saw in Isadora Duncan the perfect expression of human nature: she "rendered dance more sensitive to the figure, and she is simple like classical Antiquity, the very synonym of beauty."[32] It is known that in this same year, Alda Moreno, one of the acrobat-dancers working at the Opéra-Comique, also posed for Rodin and inspired a series of his sculptures.

In 1906, Rodin confided in Edmond de Goncourt that his sketches of the Cambodian dancers had not "sufficiently comprehended their exoticism."[33] At the same time, he affirmed that their performance had "restored the ancient" for him by "revealing the mystery."[34] These remarks were made, as we have seen, in the context of Paris at the beginning of the twentieth century, giving a particular and rather ambiguous meaning to the notion of exotic dance. This term appeared for the first time between 1888 and 1895 at the Folies Bergères, in a music-hall programme announced as "The Lotuses, exotic songs and dances…"[35] without specifying the

geographic origin. The first dance to be truly termed exotic was the "cake walk", introduced in France in 1902, followed by all those coming from the United States, such as the tango.[36] Very quickly, "exotic dance" would come to include American, African, Spanish, Javanese, Oriental, Persian, Hindu and Japanese dances. The polysemy of this terminology attempts in vain to combine a flagrant ignorance of all these foreign cultures. Some of these were associated with lands that were no longer politically autonomous but rather subject to colonial domination. Such is the case with colonised India, as the nation of India would not exist until 1947. Thus, there would be no precise geographic understanding of this "elsewhere", and even less definition concerning the origin of these dances termed "exotic".

When people speak today of "Indian dance", this syntagma relates to no artistic reality: it would be more appropriate to specify *bharatanāṭyam*, *odissi*, *kathak*, or another style. But one must understand that at the time when Rodin could have attended an exotic dance performance, the criteria for authenticity were connected less to a specific cultural and personal origin than to the dark colour of the dancing body and to the costume worn by an artist. An artist could wear numerous costumes in the same performance, passing from Cambodian to Greek to Persian; the essential goal was to call forth a feeling of amazement that well surpassed the object under consideration. In this type of travel-in-place offered by the grand world's fairs at the beginning of the century (connected to the ideology of colonialism), what counted was the exotic effect at any price, even by falsifying the aspects of performances. But it is clear that Rodin sought something beyond the stereotyped images of exoticism, something ancient, more than exotic, similar more than different, intimate more than far flung. And he was careful to explain this to the reader of his "Dance of Shiva":

> *On the supposedly barbaric art of Shiva:*
> The ignorant man simplifies and crudely observes; he strips away the life of a superior art for love of something inferior, and realizes nothing. One must study further in order to take deeper interest and to see …

RELATIONSHIPS AMONG THE RODIN DANCE MOVEMENTS SERIES (1910), SELECTED RODIN DRAWINGS INCLUDING THE SEVEN STUDIES OF CAMBODIAN DANCERS, AND THE 108 POSES OF SHIVA

Drawings and sculptures of dance

FACING PAGE (FIG. 6): "Element A", *Dance Movements*, Rodin

BELOW RIGHT (FIG. 8): *Karaṇa* 65, Chidambaram Temple, Tamil Nadu

(FIG. 7): Swarnamukhi, *karaṇa* 65, Tanjore Temple

Among the *Dance Movements* sculpted in 1910 by Rodin, "Element A" (fig. 6) resembles some acrobatic figures of the god Shiva, sculpted in the great temples of south India, such as those in Chidambaram and in Tanjore. These Rodin sculptures were never exhibited during his life, and no citation of his enables us to connect them to a certain style of dance.[37] Asexual, they tend to reflect the sculptor's conception of dance. However, certain aspects do resonate with the bronzes of the god Shiva. The repertoire of a few rare artists testifies to such flexibility: K. Swarnamukhi, a dancer from Tamil Nadu, performed these sculptural postures in the temple at Tanjore (fig. 7),

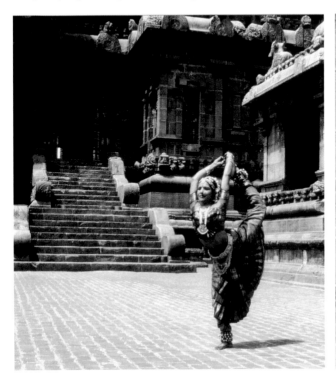

on the occasion of the filming of *The Dance of Shiva*, the 1985 film by French director Lionel Tardif.

Knowing these numerous postures, it was impossible to simplify the lord Shiva's dance to a unique pose. The very fact that there are at least 108 postures, each with numerous possible meanings, enables us to understand the verity of Rodin's abstraction of their symbolic meaning, as the *karaṇa* explores all sorts of possible movements, and the *Nāṭyaśāstra* that incorporates them itself insists upon the creativity of the artist. In our creation "Shiva-Rodin", Rodin's drawings were interpreted onstage as particular moments in the development of a *karaṇa*: this first example is illustrated by these two photographs, in which one foot raised behind the body touches the head. This is the 65th *karaṇa*, *vidhyubhrantā*. Two variations of the same *karaṇa* can be observed in the sculptures at the top of one of the entry towers of the Chidambaram Temple (fig. 8): they are performed by the goddess Parvati, consort of Shiva. According to the guidelines of the *Nāṭyaśāstra*, Shiva conceives of the postures and it is then the role of the woman to manifest them, in the form called *lasva*, meaning gracious and supple.

Fourteen of Rodin's drawings show the same bodily pose as *karaṇa* 65, including *Airplane* (fig. 9) and *Flower of the sky/The sun* (*Fleur du ciel*) (fig. 10). Four of them are entitled *Posture of bearing arms*, and in at least one case, it shows a naked woman in profile. To give the impression that the leg, from the knee to the foot, is held over the shoulder and backward, like a weapon, Rodin slightly modified human morphology. The sculptures of the 108 *karaṇa* in the Hindu temples—particularly at Chidambaram and Tanjore—are carried out in the same fashion, especially when one leg is raised behind the body to the level of the head: neither the pelvic twist nor the height of foot is possible in reality. The temple sculpture presented at the uppermost level is an example. On another of his drawings, Rodin wrote on the

(Fig. 11): One of the sculptures in the *Dance Movements* series, Rodin

lower right, "Wind/flower of the/sky/its torch."[38] Another work of the same genre, *Like a pure crystal*, bears the following annotation: "Like a pure crystal/like a vase of/champagne/delight/flower."[39] Rodin created a third version of this pose, seen from behind, with two drawings—graphite on watercolor and one paper—entitled *Psyche*.[40] Note that Rodin used this same title for numerous other drawings of nudes in other postures.[41]

As for *karaṇa* 44, "Scorpion with a liana", one of the 1910 *Dance Movements* (fig. 11) and three drawings refer to a symbolism created by Rodin: *Spring*[42], annotated by the artist on the right and across it; *Aviation*[43] (fig. 12) noted also at the bottom right: "supreme balance - emblem of power - aviation." The third is named *Ardor of the Sky*.[44] These references are rooted in the context of the time and the new appeal of modernity: the very beginnings of aviation and the appearance, in 1913, of aerial acrobatics, with the new possibility of seeing the world not just from a height, but upside down. Rodin may be alluding to certain paintings by Delaunay on this theme: the series of the Eiffel Tower in 1910 and then his sketches and oil paintings on the Cardiff Team in 1913, in which we see the players assembled around a triangular form, which is projected toward the sky by a sinusoidal curve that reaches across the median vertical axis of the image. Between 1914 and 1915, the painter Malévitch also created an abstract composition entitled *Flying Airplane*.[45]

According to the Indian tradition of the *Nāṭyaśāstra*, *karaṇa* 44, "Scorpion with a liana" (fig. 13), is used by actor-dancers to represent the act of flying in the air.[46] Goloubeff's text with in *Ars Asiatica III*, entitled "The descent of the goddess Ganga to Earth", describes the great sculpted rock of Mahabalipuram in South India and the characters thus represented: at the top are the musicians and the celestial dancers.[47] The majority of them have one leg raised to the back and bent at the knee, representing movement through the air. Goloubeff describes the scene in this way:

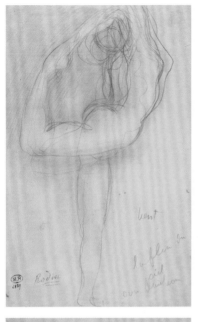

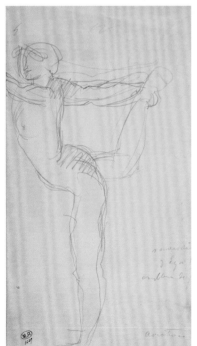

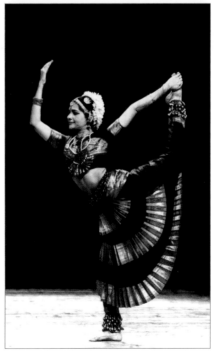

Top left (Fig. 9): *Airplane*, Rodin, D. 4998

Top right (Fig. 10): *Flower of the sky/The sun* (*Fleur du ciel*)*,* Rodin, D. 2829

Below left (Fig. 12): *Aviation*, Rodin, D. 1629

(Fig. 13): *Karaṇa* 44: Swarnamukhi

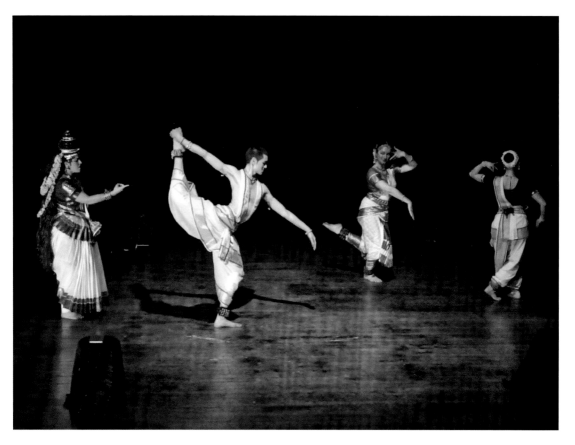

(Fig. 14): Performance of
"Shiva-Rodin", Paris, 2012

All these bodies, uncountable, are engaged in the same movement, by the
same rhythm as that of a marching army. Toward the top of the rock, the
movement becomes a leap. The rapid walk becomes flight, and one thinks
of the Kalidasa verse: "They traversed the sky like swords."[48]

In one of the scenes of the original performance "Shiva-Rodin" dedicated
to Rodin's drawings, we choreographed this bearing, belonging to *karaṇa*
44, to one of the *Dance Movements* of 1910, and to the three drawings by
Rodin, performed in the *bharatanāṭyam* style by the dancer Sanga. (Fig.
14) This pose is often represented onstage in India as it is in Cambodia.[49]
Several of Rodin's drawings of the Cambodian dancers show this, as well
as those of the "dance of the birds", included in the programme of their 6

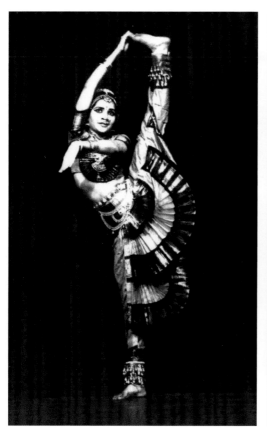

July 1906, performance at the Pré-Catelan, Théâtre de Verdure.[50] Rodin also possessed a postcard[51] from Cambodia titled "Royal Dancers in the Dance movements", in which these artists took the same position of the foot raised to the back, following the same diagonal line as the wing of their costumes.

Here too is an example of one of the possible sources of inspiration for Rodin's text. In January 1914, he purchased 15 wooden sculptures that had been part of the procession floats in the Hindu temples. In the above images, we can observe the same pose with different materials: the dancer Swarnamukhi, playing the role of Shiva, demonstrates the 50th *karaṇa*, *lalāta-tilaka,* "Mark decorating the front/forehead."[52] (Fig. 15 and 16) One leg is raised straight up, and via a difficult rotation of the hip, the foot comes

(Fig. 15): *Karaṇa* 50, Swarnamukhi

Above left (Fig. 16): *Karaṇa* 50, Swarnamukhi

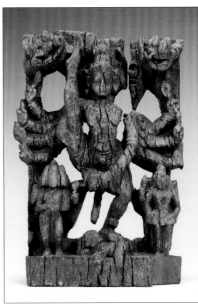

(Fig. 17): Sculpture from the Chidambaram Temple

Above right (Fig. 18): Wooden sculpture purchased by Rodin in 1914

to touch the back of the head, as the big toe touches the face to imprint the red dot symbolising the third eye. The foot is held above the head by both hands, as seen also in the stone sculpture from the Chidambaram Temple (fig. 17); Shiva would have used this pose to compete with his female consort Kālī. On one of the teak wood pieces purchased by Rodin (fig. 18), the presence of the eight hands holding numerous implements of war shows his terrifying dimension, the destroyer of established forms.[53] Indian mythology, passed down in the *karaṇa*, interprets this as the action of flying in the sky, that of transforming into a scorpion, a serpent, or a circle of flames.

The Seven Studies of Cambodian Dancers
Following Rodin's attendance at the Cambodian royal ballet performance of the King Sisowath's court dancers in Paris and at the Colonial Exposition in Marseilles, he made 150 drawings, beginning in 1905. (Fig. 19) Among all these drawings, to our knowledge, only one shows a Cambodian dancer in the pose of Shiva Naṭarāja: *Seven Studies of Cambodian Dancers*. (Fig. 20) However, it is indeed possible that certain drawings are related to other

phases of dances of Shiva. Rodin understood the link in their art between sculpture and dance, the idea that a pose is but one suspended moment from a succession of movements.

The Shiva Naṭarāja is justifiably present in the Cambodian art form to the extent that the movement vocabulary utilised by the Cambodians was based upon the same text as used by the actor-dancers of India: the *Nāṭyaśāstra*, millennial treatise on the theatre and dance of India. It indexes 108 poses and steps ordained by the god Shiva. They are presented as variations of this dance figure, like 108 profiles of this divine model, around which the dancer turns in order to perform them.

Consequently, the pose of Shiva Naṭarāja would be a fragment of a choreography, inseparable from the movement that preceded it and from the one that followed it. Rodin's comment about a dancer in his 1914 text "Dance Frescoes" speaks to this interpretation: "It re-utilizes its attitudes. In repeating things, they are moderated. This is the secret of Dance."[54] That is the reason why, in his drawing *Seven Studies of Cambodian Dancers* (*Sept études de danseuses cambodgiennes*), 1906, Rodin may have imagined several sequences of the same movement.[55]

One of the figures in blue is the only one in horizontal position, without a doubt, because she is the first or the last pose and she can match

BELOW LEFT (FIG. 19): Rodin drawing the Cambodians in Marseilles in 1905

(FIG. 20): *Seven Studies of Cambodian Dancers*, 1906, Rodin

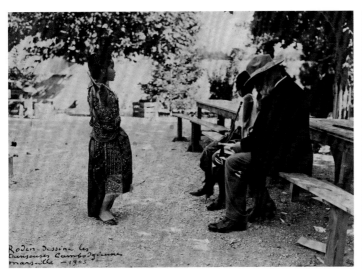

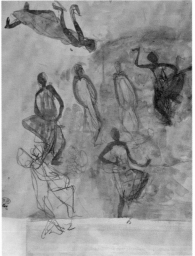

(Fig. 21): Hindu deities. Teak wood panel. Rodin's collection

the pose of Shiva Naṭarāja. But at the same time, she is inseparable from the other drawings. They function as binaries: there are two dancers in blue costumes, two in yellow, and two in pink. Although the positioning of their arms is different, those in blue and in pink show the same positioning of their legs, categorised in India as *urdhvajānu* (with the knee lifted to the side) to represent the god Shiva as a king seated on his throne—which may correspond to the attitude of the dancer in rose.[56] One hand rests upon the raised thigh while the other arm is raised above the head, showing the crown, the power, the action of threatening, or Shiva holding his consort Pārvatī sitting on his thigh. One dancer in pink performs *bhujangatrāsitā*, which often comes before or after the raised leg of Shiva Naṭarāja and signifies "The fright of the serpent".[57] In two of the wooden panels acquired by Rodin in January 1914 (fig. 21), one side shows the goddess Gaṅgā, while the other shows a figure performing *karaṇa* 25 with a raised knee. But as the figure holds nothing in the hands, it is difficult to ascertain whether Shiva is indeed being represented here.[58]

In January 1914, Rodin acquired the sculpted Indian wood panels with deities, and his text "Dance Frescoes" was published in the review *Montjoie*. "Frescoes" was written at around the same time as "The Dance of Shiva", which was in the autumn of 1913, according to Victor Goloubeff. But he would have been able to start his preparations in 1911, when Goloubeff gave him the snapshots from India, and continue with the project until 1914, the year he wrote and published his final book, *The Cathedrals of France*. What's more, in "Dance Frescoes" Rodin looks back on the dances he saw in 1886 and in 1906

and he creates a kind of collage of written impressions over time.[59] In the text, he describes at length two original movements that, in his eyes, characterise the dances of Java and Cambodia: trembling and snaking.

In the first case, "they are the tremors given by the body and in which it descends" with variations in tapping the feet, rhythmic shaking of certain parts of the body dissociated from other parts, giving the impression of functioning autonomously. For example, the shoulders may shake, and at another moment the hands shake, or the neck moves very quickly from side to side. Or again, balancing on demi-pointe, the dancer performs small striking jumps. Rodin sees that all of these vibrating modalities have been conceived in order to transform the dancer's body into a particular character. He remarks several times on the constant position of the legs in demi-plié: "these bent knees are a reserve of expression" in the sense that they enable the body to grow suddenly and enable the dancer to change roles, to incarnate a hero or a god.

(FIG. 22): The god Shiva burns the body of Kāma. Sanga and Manochhaya. Performance of "Shiva-Rodin", Paris, 2012

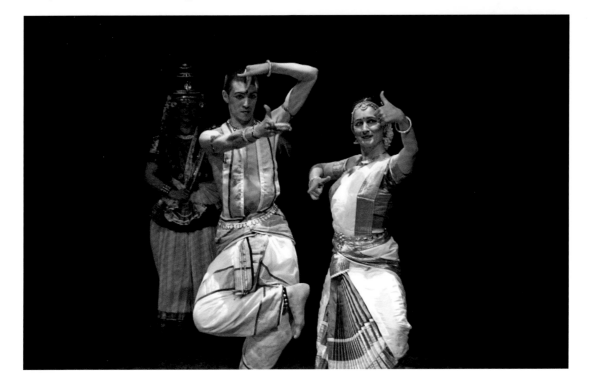

For example, to show the god Shiva in anger, so disturbed from his meditation by the god of love Kāma that he burns from his third eye,[60] the dancer creates vibration via a movement of the right arm as if he had been struck by lightning. The entire body seems to be overtaken by this shaking, while he moves forward with very rapid small jumps. (Fig. 22) This scene is represented on one of the wooden panels purchased by Rodin. (Fig. 23)

(FIG. 23): The god Shiva burns the body of Kāma. Teak wood panel

Particularly in the *Rāmāyana,* this technique is used to play the role of the monkey Hanumāna, turning about while progressively bending the knees to take the form of a very small monkey, as he secretly visits Sītā in prison on the island of Sri Lanka. Then, to show his transformation into a giant monkey before the army of the demon Rāvana, the dancer turns while jumping, raising himself on the tips of his toes. Rodin considers this position in "Dance Frescoes": "The bent knees lift up in extraordinary rhythms." He also mentions how the dancers, offstage, resemble small vivacious boys with short hair; "onstage, a divine majesty makes them unrecognizable." In his eyes, this process is due to the onstage presence of their prince, who reminds the artists of the divine origin of their dynasty. The second "unknown" movement, in Rodin's view, is the following:

When the arms are extended into a cross, they resemble a movement that snakes from one hand to the other, passing by the shoulder blades. This movement comes from the Far East, unknown, never before seen; this is to say that when a movement of the left arm

makes a concave axis, the other makes a convex axis, and these animate the arms, and the burst of movement passes in the shoulder blades.[61]

This snaking movement is the title that he gives to one of his drawings in an article in *Illustration* on 28 July 1906, *Bust of a dancer* with one hand in *haṃsāsya* (thumb and index finger joined) and the other in *patāka* (fingers outstretched and tight), terms that are identical in the dance-theatre of India. The arms are extended horizontally.[62] The Cambodian Proeng Chhieng explains in his article[63] that the movement is that of the serpent *nāga* wriggling its tail.

A series of fragmentations

"A fracture always happens by chance: but chance is quite artistic."[64]

Rodin conceived his poetic writing on Shiva in the form of sparse phrases, separated by blank spaces and scattered across the paper, without continuity among them. The only coherence is given by the angle from which each photograph was taken: "Viewing the full Shiva", "Viewing a profile of Shiva", "Facing Shiva", "On contemplating the head of Shiva at length" and so on. But these do not exactly correspond to the succession of 12 photographs presented in the *Ars Asiatica* review.[65] Rather than penetrating the mythical dimension of the history of symbolism attached to each element of this body in movement, Rodin lingers to reveal a form seeking its limits, a movement as it is being made, a sign detached from its typical significance:

> In sum, these are the virtues of depth, opposition, lightness, power that count; but not of these details that are only useful for themselves, veritable useless embellishments if they are nothing in relation to the movement.[66]

Rodin's text, "The Dance of Shiva", seeks to express ideas on dance, rather than on the rules of composition of an Indian art. Its poetic writing, voluntarily placed outside the passing of time, detaches the bronze from its chronological contexts in order to bring forth the ideas that it incarnates. With reference to the wooden Egyptian sculpture, *The Falcon*, part of

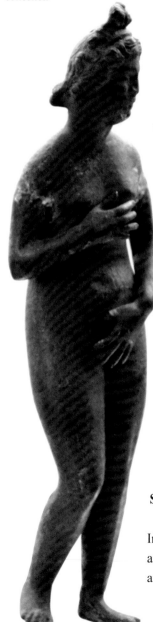

FACING PAGE (FIG. 24) AND BELOW (FIG. 25): Profile of one of the bronzes of Shiva that Rodin associated with one of the Venuses of his collection

Rodin's personal collection, Bénédicte Garnier reminds us that this artist was interested less in the object than in what it represented.[67] In interviews with Paul Gsell, Rodin expresses it thus:

> Observe the forms of that bird. It is not a sparrowhawk, it is The Sparrowhawk, it is The Bird of Prey: a formidable beak placed directly, to say it thus, upon a pair of wings and a pair of talons.[68]

At the time that Rodin was writing his text on Shiva, he enjoyed comparing his research on "the architectural aspects" of the human body with those of the ancients, focusing on the "'core' of each form, the very essence of its appearance, fretting little over the details of the object that they actually had before their eyes."[69] This is why the author was not interested in the codified aspects of this statue from the Hindu pantheon. He cites neither its ornaments nor two of the four hands holding the fire and the drum. When he twice mentions the word snake, it is to describe the mouth of the god Shiva, which, "undulates in the humid delights," and not the cobra that decorates the right forearm of the first bronze and the crown of the second. On the other hand, Ananda Coomaraswamy, whose text follows Rodin's in *Ars Asiatica III*, describes this attribute in a symbolic fashion: "the cobras, symbols of death and reincarnation, twist around him." The following study by E.B. Havell describes the head of Shiva coming from the grand temple of Elephanta: "Other serpents are rolled in the spirals of curly hair and in the ornaments of the mukuta [hair bun]."[70] But in his text, Rodin does not state what he truly sees of this statue. He imagines its "lips that form words, that move when they escape. Such a delicious serpent in motion!"

SHIVA AND THE VENUS OF MEDICI

In his text, Rodin opposed two figures that are among the most famous and and influential of their traditions, one Greek, the other Hindu: Shiva and Venus. (Fig. 24 and 25) He engages in particular with the role of their

gesture that seems to designate and/or conceal the chest and genitals of these two bronze bodies. The ambiguity of the movement comes from the shadowplay cast across their thighs and their hands, which "touch the light." Among the 27 photographs of Shiva that Rodin contemplated, the placement of the lighting source varies, but in the image that inspired the connection with Venus, the electric light is beamed from above and on one side, emphasising the multiplicity of possible viewpoints of the same figure. Thus, of the raised leg and the movement of the foot crushing the demonic dwarf, Rodin seizes upon only the mobility of the chiaroscuro, playing between the two legs of Shiva:

> The thighs, so close together, a double caress, jealously enclosing the shadowy mystery; the beautiful field of shadow rendered more evident by the light upon the thighs.

When Rodin compares the two hands of the God with that of the Venus of Medici who "shields her beauty"[71], his interpretation is based only upon the placements of the light, which, in the case of the specific snapshot that Rodin had access to, shows shadows dropping towards the pubis. In Indian iconography, the position of these hands symbolises the action of casting away fear (*abhaya mudrā*): the palm of the hand is not inwardly oriented as in Venus' pose, but towards the exterior. The God thus addresses any being seeking his protection. In the gestural vocabulary shared among the Indian art forms, this *hasta*, called *patāka*, literally "banner", has several meanings depending on its orientation, which can change in a matter of seconds: refusal, indication, shield. The left hand of the diagonal outstretched arm points towards the raised

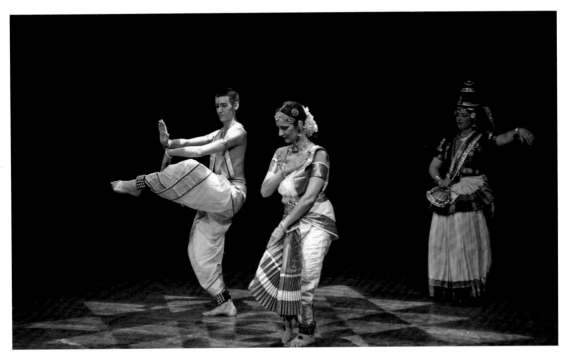

(FIG. 26): The god Shiva and the Venus of Medici, Sanga and Manochhaya, performance of "Shiva-Rodin", Paris, 2012

leg, symbolising the liberation of the body from terrestrial gravity. It is called *gaja hasta* (elephant trunk) or *daṇḍa hasta* (staff-handed); like the elephant-headed god Ganesh, son of Shiva, it removes all obstacles from one's path.

On the other hand, the gesture of the famous Venus of Medici hides the chest with the right hand and conceals the genitals with the left hand, as she protests herself from exterior stares. It is likely that the bronze profile Rodin writes about could lead one to believe that the same gesture is therein present. But an optical illusion is present: the right arm of Shiva also seems to cover the top of his chest, with his left hand placed at the top of the raised thigh. However, in Rodin's personal collection was another profile, shot from a perspective that represents a shift of a few centimeters from that of the first image.[72] The left hand thus appears moved from this change of view, enabling the viewer to see between the legs and the multitude of small cords encircling the hips. Termed *kati-sūtra* in iconographic vocabulary, this manner of dressing the hips includes small cords covered in pearls,

bells, small chains, or even in curling snakes. A reference to Venus was possible only at a precise, unique moment, that when the photographer walking around the Shiva statue stopped at the point of this profile, which did not at all match the angle of the photo published in 1921 in Goloubeff's review. In the performance "Shiva-Rodin", these Greek and Hindu legends are performed in the *bharatanāṭyam* style by Sanga (playing Shiva) and Manochhaya (in the role of Venus). (Fig. 26)

One thing is quite apt in this connection between the antique Venus and the bronze Shiva: the feminine aspect of the god of dance, which is manifested in India in several ways, according to the sculpted poses and the symbolic functions of this deity. When he is sculpted in his *ardhanāriśvara* form, he becomes "half-man, half-woman". His feminine side is visible on the left side of the body, in a gentle sway of the hips and a rounded breast. On plates V, X, and XI of the bronzes studied by Rodin, and certainly on the close-up of the face[73], which was not published in the *Ars Asiatica* review, a feminine element is visible: the left earring, the voluminous circular shape of which is noticeably different from that on the right, which is much simpler and u-shaped. (Fig. 27 and 28) The

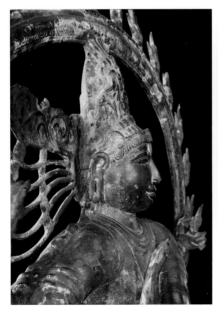 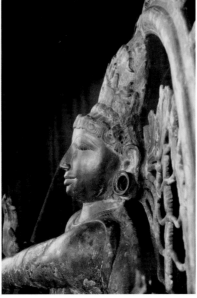

(FIG. 27): The circular left earring of Shiva Naṭarāja visible in a side profile photograph that Rodin received from Goloubeff

BELOW LEFT (FIG. 28): The U-shaped right earring visible in another snapshot of Shiva Naṭarāja studied by Rodin

left-side jewel is the same type as those worn by goddesses. Rodin in his text cites only "the curve coming from the ear traces a small curve that pulls at the mouth and a bit at the wings of the nose," while Ananda Coomaraswamy is more precise in his *Ars Asiatica* text, contemplating the same photographs:[74]

> In sculpture, the duality of the sexes is expressed by an ornamented earring, borrowed from Hindu ladies' finery - typically attached to the left ear of the god.

Similarly, the following text, written by E.B. Havell, mentions "the large ring (*kamala*) suspended from the ear (…) a characteristic piece of feminine dressing."[75] According to the rules of Indian iconography, the left earring is made with a shell (*samkha-patrika*).[76]

Three Venuses from Rodin's collection of antiquities
In his personal collection of antiquities, Rodin had three Venuses of the Medici type: the small bronze seen in the photo in his Meudon home—which is discussed at the beginning of this chapter in relation to a photograph of Shiva—and two fragments.[77] (Fig. 29 and 30)

In the interviews with Paul Gsell, Rodin explains how one day, he had invited Anatole France to visit his home in Meudon to see his collection of antiquities. Anatole France commented at length on the small goddess torso, which we know initially included a left hand (now missing) that held a piece of clothing. (Fig. 31) Mr France defined it as "one of the innumerable modest Aphrodites that, during Antiquity, relatively freely copied Praxiteles' masterpiece *The Aphrodite of Knidos*, in the sixth century before our time," which was shown in the temple at Knidos dedicated to Aphrodite. He

FACING PAGE (FIG. 29) AND BELOW (FIG. 30): Two Venuses of the Medici type in Rodin's collection

recalls that she was indeed the model for the Venus of Medici.[78]

Paul Gsell further specifies that this statue was placed upon a pedestal, in a corner of the atelier, and that "Rodin kept it there in order to inspire him while he worked," observing the smallest details with the aid of the electric lamp: "the infinite undulations" and "the voluptuous curves of the hip."[79] Rodin saw body parts not as surfaces but as "projections of interior volumes," an idea that is also well-represented in his text about the Shiva. The play of light and shadow gives life to the statue and sets it to dance.

Let us return more specifically to the text on the cathedrals, regarding the hands of the Venus and of Shiva, which Rodin defined in terms of challenge, of confrontation, of tension between light and shadow, the visible and the invisible. The hands of two praying women, the hands joined upon the chest in the cathedrals text become in the Shiva text those of the God himself; as for the "ingenuous prayer" of the women, this becomes the "ingenious gesture" of the cosmic dancer. Here, the role of the feminine is to bring together, to unite man with himself, with the world and with the divine, while Shiva separates his hands to affirm the superiority of the divine and to pour out protection and benefits to humankind. A female contemporary of Rodin's may have corresponded to this feminine model; recall that in 1911, when Goloubeff gave Rodin his photographs of the Shiva, Rodin saw Isadora Duncan and her dancers and found in them a Greek inspiration, the perfect expression of human nature: she "rendered dance more sensitive to the figure, and she is simple like classical Antiquity, the very synonym of beauty."[80]

In his text on the cathedrals as well as in the text on the Hindu god Shiva, Rodin speaks of the shadow projected upon the divine body and upon the feminine body, which serves to separate two worlds: as seen in

the close-up of the body of Shiva, these correspond to the bright hands and thighs, thus connected to movements in the visible, material world, while the heart remains in the shadows, symbolising the interior world of his spirituality.

But this play of concealing and revealing depends on the origin of the light source and upon the angle of view that is chosen to contemplate the body. Full light is reserved for a divine regard, as we see in Indian theatre. In fact, these Venus-type arms are quite familiar to actor-dancers in India in order to tell the story of the child Kṛṣṇa of the *Bhagavata Purāna*: the shepherdesses emerge from the river with the same gesture as Venus when they realise that Kṛṣṇa has stolen their robes. They must show him their nudity by putting their hands upon their heads before he will accept to return their clothes to them. The revelation of their private parts is inseparable in this story from the opening of their hearts to the God.

This reunion into a single spiritual body of Venusian and Shivaistic forms as seen by Rodin corresponds in India to the figure of *ardhanāriśvara*, Shiva as half-man and half-woman. An example of this can be drawn from the stone statuary in the Gangaikondacholapuram temple dedicated to Shiva. (Fig. 32) It dates from the eleventh century, like the two bronzes studied by Rodin. Shiva has three hands: the masculine part holds the *paraśu* axe that severs man from the bonds of attachments and desires. His other hand rests protectively upon the head of his mount, the bull Nandi. Pārvatī has but one hand, which holds a lotus, symbol of beauty, calling to mind the water lily previously described, while a parrot grips her wrist. If Shiva's role here is to deliver man from his earthly ties, the role of Pārvatī, the left part of Shiva, is to connect the divine and human worlds with those of flora

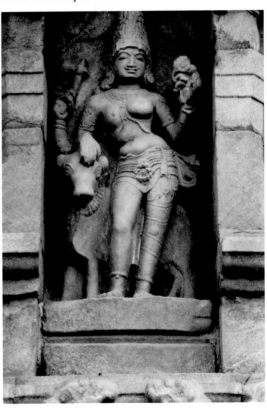

(Fig. 32): *Ardhanāriśvara,* Gangaikondacholapuram Temple, Tamil Nadu

Facing page (Fig. 31): Medici-type Venus from Rodin's collection

and fauna, which is expressed in the undulating line across her body, visible in the tilt of her hip and an ample breast and continuing in the roundness of the flower and of her hand. One of the wooden panels acquired by Rodin in 1914 representing the goddess Gaṅgā is also constructed upon a triple curve, emphasised by the line of the foliage growing on one side and the liana that counterbalances on the other. (Fig. 33)

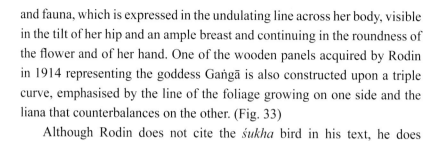

(Fig. 33): The goddess Gaṅgā. Teak wood panel from Rodin's collection

Although Rodin does not cite the *śukha* bird in his text, he does mention the bee, which he imagines continually entering and exiting the mouth of the bronze. It is indeed traditional for the hand of the Indian dancer to show the *bhramara* bee in the same manner as a parrot, for they share the same function: to indicate knowledgeable speech, the voice of wisdom, whose message is transmitted via loving hearts (transformed into a lotus and pollinated by the beloved.) The hand thus conceals and contains these secrets. In Sanskrit, it is also called *kara* "that which causes" and *mudrā* "that which seals". Recall that among the hands sculpted by Rodin, those that nearly touch one another are called "Cathedral".

Among Rodin's wooden Indian artworks that have already been mentioned, there are two sculpted pairs (Co. 105) that also represent this *tāṇḍava/lāsya* polarity, with one representing the strong and terrifying character of Shiva and the other characterising his feminine aspects, full of gentleness and grace. In Rodin's text, aside from the mention of Venus and the role of hands shared by Venus and Shiva, it is fundamentally one phrase that brings us to the figure of *ardhanāriśvara*, when he describes the mouth of Shiva: "Mouth, lair of the sweetest thoughts, but also a volcano of rage." At the conclusion of his interviews with Paul Gsell, Rodin repeated how much he sought the serenity of ancient items; in the very first phrase, he exclaims: "In the full bloom of life, the flow of life, the air, the sun, the sense of *being* simply overflows. This is how the art of the Far East appears to us!" In the original

French, Rodin begins with a form of the verb *épanouir*, which means both *to blossom* as well as *to give pleasure*. Such semantic and symbolic connections run throughout both the Shiva Naṭarāja and Rodin's text, both works, in search of the equilibrium between—on one hand, a fire that separates and dissolves beings, and on the other, the breath of a muse who dares to reunite them.

Broken shapes or unfinished ones?

Numerous works of Rodin speak of the same principle of unconstrained creativity as seen in his text on Shiva. The repetitive structure of interruptions between phrases, breaking up the rhythm of the narration and corresponding to changes in points of view or to photographs fragmenting the body into smaller parts, can also be seen in the sculptor's artworks. Guillaume Apollinaire saw his 1910 Salon as "a fragmentary work."[81] And Rainer Maria Rilke defined Rodin's modernity by the idea of incompletion, by "the fragment becoming the artwork."[82] The sculptor finished himself by conceiving of his own life as "a mosaic of black stones."[83] When asked why he sculpted torsos without heads, he responded, "The head? But it's everywhere!"[84] He added that the expression of a face is read through the curve of muscles, whether flat or in flight. And the inverse is true as well: "even in the least significant head, there is still life, magnificent power, inexhaustible material."[85]

For Rodin, dance held this quality of incompletion, as explored in his 1910 *Dance Movements* series: these works were not only to show a series of partial and momentary movements, but also to push the limits of the human body's morphology. The different extensions of a leg to one side, behind, or in front of the body can give the illusion of a rhymically connected sequence of postures or movements. But a second, more attentive reading enables us to glimpse the impetus of these bodies to go beyond pre-defined forms, to suggest other bodies beyond social norms. Their originality resonates with the dance of "The Afternoon of a Faun" performed by Nijinsky; despite the scandal of this choreography at the Théâtre du Châtelet in Paris, Rodin came to Nijinsky's defence.[86] The daring, innovative movements that Nijinsky used to play the faun were characterised by turned-in feet, bent body,

angular gestures, head leaning to one side and sensual movements with the pelvis. They were quite different from the movements that he performed in the role of Kṛṣṇa in "The Blue God", a ballet by Michel Fokine. His body painted blue, he had remained perfectly still, like a living sculpture, in the position of the flute-playing God, until the end of the performance when he came to reunite the two lovers that had been separated in the story. Rodin admired the innovative force of this dancer, like Isadora Duncan and Loïe Fuller. According to Rodin, these three artists had found "the sense of a tradition based upon respect for nature" and conceived the body according to "the beauty of frescoes and the statues of Antiquity"—"an ideal model that one wants to draw, to sculpt."[87]

As evidenced by Rodin's correspondence with Hélène de Nostitz, niece of chancellor Von Hindenburg, she became Rodin's "great and intellectual friend" around 1900.[88] In 1903, she posed for a sculpture of her bust and then often invited Rodin to Italy, to stay in her family's residence at Ardenza near Livorno. She translated passages from Dante for Rodin, and he saw in her a "new Beatrix", "the divine propagator who sows love in our heart that returns a hundredfold beyond our artworks."[89] Rodin often confessed to her the extent to which ancient statues,[90] broken and incomplete, had become essential to him:

> Now I have made a collection of mutilated gods, in pieces, several of them, masterpieces, I spend time with them, they teach me and I like this language from two or three thousand years ago, closer to nature than any other. I think I understand them, I visit them constantly, their grandeur is soft to me, and there is a rapport within them with everything I love. These are the morsels of Neptune, of goddess women.
>
> And all of this is not dead, they are alive, and I enliven them even more, I complete them easily, in vision, and these are my friends to the final hour.[91]

These Greco-Roman sculptures that have come to us in fragments, inspired Rodin's concept that an artwork achieves perfection in its very incompletion.

When words fail us

In the middle of the text on Shiva, Rodin confesses that he is at a loss for words. In the midst of great inspiration, the importance of this return to silence brings to mind the manner in which Rodin approached his models, circling around them as he sought every possible profile view. As it happens, the artist's multiple revolutions were hardly tolerated by his models towards the end of his life.[92] Rodin also referred to this loss for words when he viewed a dance performance. In the January-February 1914 edition of the review *Montjoie*, remembering the Javanese and Cambodian dances he had discovered several years ago, he remarked that it was in "seeing the dances of the Orientals" that he realised that "the body that dances can, with movements, express more than words." He added that in this way, dance "summarizes" the other arts.

In "The Dance of Shiva", Rodin indeed stays closest to his own thoughts on sculpture, but the loss for words that he indicates is deeply relevant to the Indian aesthetic, for in contemplating this image of the Shiva Naṭarāja we realise that it is impossible to name it. The text from Coomaraswamy that follows Rodin's in the *Ars Asiatica III* review emphasises this point, using two citations describing the God:[93]

> Here is the Supreme Being; Here is the most ancient of Gods who cannot be described in words;
>
> Lauded be the one who exceeds word and thought;
>
> He has no beginning, no property, nor end;
>
> He has neither name nor form nor any characteristic whatsoever.
>
> He is varied: once, twice, multiple, a thousand, a million times over. Such is the *Māhâdeva*, the Immense, the Divine, he who exists without being born. One hundred years is not enough to describe all his qualities.

As Rodin moved closer to what he called "the secret place reserved for the Unknowable,"[94] he confessed to Paul Gsell that he considered himself a religious person and that his beliefs resonated with the Shivaist approach discussed above. In addition, he defined "religious" as follows:

It is the feeling of everything that is unexplained and without a double inexplicable in the world. It is the adoration of the unknown Force that maintains the universal laws, that preserves the different types of beings; it is the suspicion that everything in Nature does not fall within our physical sense, a suspicion of the immense territory of things that neither the eyes of our body nor even the eyes of our souls are capable of seeing.

In *The Cathedrals of France*, Rodin explores one particular link between the angel of the Chartres Cathedral and the Cambodian dancers: from these two expressions of ancient art emanate a "profound belief in the unity of nature"[95] synonymous with traditional and religious sentiment. It concerns human nature, with "its joys, its pains, its certainties." Religions have a common mission: to be "like the caretakers of great harmonious faces" and to show "the kinship of human form and actions all over the globe." It is one of the rare remarks by Rodin about the complex work of artists with respect to the face and hands. The faces of the Cambodians drawn by Rodin show little emotional variation. For he sees the essential, not in cultural and subjective expression, but in a continuity across space and time: "I have always confused art with religious art: when religion is lost, so too is art."[96]

A measured fluidity

Dance and sculpture are inseparable, a much in Rodin's work as in the Shiva bronze. Their common principle centers on the elimination of any difference between surface and depth, exterior and interior, self and world, man and universe. The emotion unleashed onstage by an Indian dancer thus derives not from a psychoanalysis of the character portrayed, but from the geometric placement of the body and the distribution of tensed muscles. According to Hindu tradition, the Shiva bronze expresses the blessing *ānanda*[97]. This infinite joy results from a trained equilibrium in the distribution of weight and bearing points, which the dancer learns to master over years of apprenticeship. In this pose of Shiva's, in order to support himself on the right foot and compensate for the weight on the right side of

the body, the dancer must contract the left shoulder and left knee, making them feel heavy, while intensifying the feeling of lightness in the hands and in the raised left foot. This subtle work with gravity cannot be too fixed or frozen, since this pose lasts for but a short moment in a choreography. The dancer's points of gravity are not constrained to technical contractions of leg and core muscles; rather, they circulate within the body, following the rhythm of the performer's inhalations and exhalations. The rhythm of movements thus brings together the perfectly proportioned, unchanging visible aspects of sculpture, with perceptions of the lightness of illumination or the weight of shadow; together they produce an instant of equilibrium, with grace and levity. In his text "The Dance of Shiva" Rodin expresses it in this way:

> The shadows move closer and closer, engulfing the work of art and lending it the charm of the deathly grace of darkness, that place where it has lingered so long …

Rodin interprets the movements of shadow across the sculpture as a sign of dance in motion, completely out of the control of the sculpture's creator or its audience; at any moment, the visible forms could disappear or paralysis could take hold, depending on the play of the light.

The artwork is a "process" revealing the traces of this rhythm, the work of opposing forces, and the resistance between these materials in contact. The ambiguity of interpretation stems from the visible traces of such eurhythmics. In *I am beautiful* (*Je suis belle,* 1882), human anatomy has not been respected, to the extent that in regarding this man carrying a woman, the viewer cannot determine whether he is putting her down or lifting her up. In the same fashion, when Rodin describes the mouth of the dancing Shiva, it is to note the double meaning: "Mouth, lair of the sweetest thoughts, but also a volcano of rage." This ambivalence coincides with Shiva's own principle: that with each gesture or each kick, he creates and destroys the word. Such juxtaposition can also be seen in two distinct parts of the body. In Rodin's phrase just cited, an Indian dancer could show gentleness in a light smile and portray anger via his eyes or even via a

continued trembling of the mouth with the corner of the lips ceaselessly rising and falling. And with the artist's imagination, the interpretations of these physical movements can multiply without end.

Among the dancers that Rodin drew or sculpted, it is Loïe Fuller who most radically manifested this research on materials in movement, far from any narrative thread. Beyond her important role as impresario for Far Eastern dancers and her invention of the serpentine dance in the 1890s, she was the originator of the theatrical concept of a luminous body, disappearing under immense veils that encircled her to suggest an infinity of possible forms.[98] In 1913, when Claude Debussy was amazed to discover the staging of his own *Sirène* by Loïe Fuller, Auguste Rodin still had not succeeded in capturing the full dynamic spectrum of Fuller's art; when she posed in his studio, he made only partial studies of her. But the manner in which Rodin in his text on Shiva associated dance and light and the changes in the shape of the dancing body—all of this resonates with Loïe Fuller's oeuvre. As we have discussed earlier, she was the fisrt dancer in the history of the performing arts to transform the human body on stage through the use of powerful projectors, eliminating any decor or storyline, in order to sculpt the space and materials with light. She is also the first artist to have "permitted the invention of a veritable photograph of dance."[99] These first shots were taken by Eugène Druet, who was at that time Rodin's official photographer.

Among the handwritten sources for Rodin's text, on the back of one of the photographs of the bronzes, there are a few lines written by the sculptor that perfectly sum up the relationship that he sees between the play of light and shadow on one hand, and the interplay of sculpture, dance, and architecture on the other. (Fig. 34 and 35) In this profile view of the bronze, Rodin attaches no importance to the bracelet with such intricately carved designs, but rather he describes a sole "line" in movement, the one beginning from the shoulder and extending up through the facial profile. He nearly goes so far as to erase the visible trace, asking us to view this line "according to the rules of geometry", "in the air", the sun and "with the eye of the divine heart". He sees beyond the drawings of the jewel in favor of contemplating the essence of the shape, contained in the idea that

this rising line, which we could not ourselves recreate, "goes to unity, to equilibrium." It is what Indian iconography calls *brahmasūtra*, the vertical line that traverses the body and its surroundings and connects the visible and invisible worlds, of humanity and of divinity, even while the body is moving and turning about itself. Rodin expresses these ideas in the text on Shiva:

(FIG. 34) AND ABOVE LEFT (FIG. 35): Snapshot of the Shiva bronze with a handwritten note by Rodin on the back

> In sum, it is the virtues of depth, of opposition, of lightness, and of power that matter; but these details are useless in and of themselves, worthless embellishments except in relation to movement.[100]

The first line written on the back of this photograph is in the same spirit: "it is in the same construction as these beauties of architecture, this line that passes before us, rising …" In his book on cathedrals, written at nearly the same time as the text on the dance of Shiva, Rodin alludes several times to the art of India, both directly and indirectly. To begin, he dedicates the first

page of his book to a description of the basis for such a sacred edifice: a living model, that of a man or a woman, balanced on one leg. This edifice "results from the counterbalancing of masses that move." What interests him is not limited to this perfect equilibrium of volumes but is founded upon the movement of shadow and light that animate Shiva in dance within Rodin's text. He expresses the relationship thusly in *The Cathedrals of France* and in an interview with Gustave Geffroy:

> In the final analysis, it is indeed always light and shadow that the sculptor, like the architect, molds and models.
>
> Art exists only in the play of opposites. Light that plays with shadow, or the inverse.[101]

This is why, be it before a feminine body or a masculine one, a live model or a sculpture, the play of light would remain his principal inspiration[102] and reveal what he calls the "law of harmony" common to the statues of Antiquity that he collected in his hermitage at Meudon:

> I look, and then I cannot leave. I am surrounded by these lights; certain ones burn out in the distance; other vibrate quite close to me.
>
> These fragments are ancients. But French or Greek, it is the same feeling, the same sphinx of beauty. Here and there, it is always nature transposed and risen from the dead. And it is this transposition that makes the supreme splendor of Egypt and India - I see all of this as if through tears of joy.[103]

A world of vibrations

Pushed to the extreme, the interplay of opposing forces described in "The Dance of Shiva" resonates with the concept of vibration more so than with that of a measured rhythm. We have already noted how the variations in luminous intensity define what is on the order of dance and not sculpture. But the description within the text never discusses a dancer whose pose concerns a myth or symbolic action. On the contrary, in his text Rodin remarks:

> There are garlands of shadows stretching from the shoulder to the hip, from the hipbone to the thigh at right angles.

If the movement of shadows could be qualified as dancing, it is not in that sense that he points out its opposition with light. Rather, he describes a sort of stationary sparkle, revealing one part of the sculpted body to the watchful observer. In these photographic shots, there is indeed a repetition of shadows. But with each phrase of the text, with each of the studied profiles, their intensities appear different to us. We could compare this process with that of Van Gogh—a painter admired by Rodin[104]—when he uses the color yellow, for example: yellow does not bring the viewer to a particular object (a field of wheat or sunflowers[105]) but to a pure rhythmic variation, oscillating between the brightest and the darkest versions of this colour. This aesthetic experience of a primary sensation of a material in the world is here synonymous with rhythm: it brings into view intense grandeur or the sensation of movement without moving.[106] This resonates with the concern that Rodin expresses to avoid choosing between two meanings of a single movement, creating what he calls "the fog of the body" with these plays of light upon the bronze. In these passages of the text, instead of opposing day and night, he broadens the perspective to include a rhythm forged by the tension between a shadow that obscures and one that illuminates; this is visible in the metaphors that he chooses.

In this way, Rodin poetically describes Shiva by comparing one part of the body to an element of nature, as seen in these excerpts: "These lips are like a lake of pleasure…the arch of the lashes…The mouth undulates in delicious moisture, sinuous like a snake…Eternally, life enters and leaves via the mouth, like bees' continual comings and goings." Such aesthetic interest given to the ebb and flow of these mineral, vegetable, animal and human worlds can also be observed in his interviews with Paul Gsell: "in Nature, it is the human body that has the most character…because by its force or by its grace, it evokes the most diverse images."[107] He cites images of a flower, a liana, a spring, an arch, and then an urn. Nevertheless, the rhythmic character of these transformations cannot be reduced to a simply periodic return to an original state, as if the human body became a bee or star only in order to later

return to its original form. This rhythm corresponds to an orderly succession, defining the passage from one body to another: for example, a ternary cycle of three in which the hand of a dancer shows a flower, a liana vine, and then an arch, independent of the dancer's body. On the contrary, far from a simple, regular passage from one shape to another, and removed from any presupposition of recorded choreography or a written score, dance requires that the dancer become the elements of the world, in an unforeseen fashion, for the spectator to momentarily forget the human form and lose himself or herself in a series that is neither narrative nor chronological.

This process means that even in a measure with three beats, the dancer-musician creates complex sub-rhythms, breaking each cycle of three into unexpected divisions: rather than the repetition of 1, 2, 3, the series could be 1, 3, then 1, 4, 4, or 1, 9. Indian music includes 175 *tāla*[108] because the rhythmic counts between each downbeat are extremely variable. Always hovering at the edge of losing himself, the artist opens the spectator—via these winding paths of destinies—to an uncontrollable, unknowable world. The spectator is propelled toward a temporary amnesia of the narrative tied to the characters portrayed (the flower, the liana vine, the arch), taken by the rhythm with its uncountable beats. The dancing body now seems to sparkle, as it passes seamlessly from one vegetal character to the next. In "The Dance of Shiva", Rodin suggests the importance of the art of percussive music when in the last part of the text, he defines rhythmically the face of the god: these sections express at times a brusque halt, at times an infinite curve, the mouth that forms a den and then a volcano, suddenly dilated by "desires of eternity", then a gaze that will speak. Such a poetic vision seems paradoxical because it is created before a sculpture whose eyes are closed, whose mouth is rigid—closed in the first bronze, and slightly open in the second. Without a doubt, such vision presumes some initial interpretation of the rules of Indian dramatic arts, in which the dancer strings together poses inspired by temple sculptures and times the beat of her footsteps with the precision of a professional percussionist.[109] This is why Rodin's poetic conception led him to repeated rhythmic interpretations and readings, in which at alternating moments, he favored dance, sculpture, architecture, photography, poetry and music.

SHIVA, THE "WATER LILY"

We have been able to trace how Rodin translated the multiple aspects of the god Shiva in terms of lines traced in a geometric space or with poetic images. He wrote "From a certain angle, Shiva is a slender crescent." However, on the back of a photograph[110] kept at his home, Rodin handwrote this same phrase but with an addition that was not published in the definitive text: "This water lily." ("*Ce nymphéa*"). (Fig. 36)

The image of a water lily, comparable in India to a lotus, corresponds in Indian iconography to a throne on which deities are seated. In the photographs of the bronzes held by Rodin, one can clearly

(Fig. 36): Rodin's handwritten note on the photograph of Shiva Naṭarāja

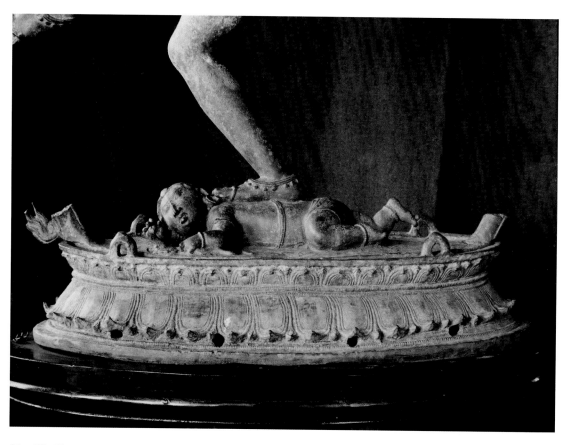

(FIG. 37): Close-up of the base upon which lies the demon dwarf *apasmāra*

see the curves of the petals of this most sacred flower of India. They are sculpted around the base that the dwarf lies upon, crushed under Shiva's foot. (Fig. 37)

But it is the God himself that Rodin describes as a water lily, not his prop! Referring to the ancient texts of India such as the *Īśvara Gītā*, Shiva is described by the great sages around him as having feet of lotus:

> They saw the sovereign Master of creatures dancing, the god thanks to whom, at the very thought of his lotus feet[111], the soul escapes the anguish born of ignorance.[112]

Then, for those "whose heart is tamed":

> They saw him with a thousand heads, a thousand feet, a thousand forms, a thousand arms: he, the god who wears the ascetic's hair, the god whose diadem is the crescent moon *candrārdha*.[113]

As the lotus is often associated with the creation myth or with divine beauty in Indian mythology, was Rodin seeking such a symbol in his handwritten note? Was he suggesting this Indian law of opposites according to which the lotus is beautiful because it begins its life emerging from muddy and unclear waters before raising itself towards the light? Was he contemplating the idea that Shiva is divine and free from gravity because he first crushes the monstrous dwarf *apasmāra* with all his weight? The Bhagavad *Gītā* confirms it in this manner:

> Whosoever dedicates all activities to the Ultimate Truth, giving up attachment, will not be affected by sin, just as a lotus leaf is not affected by water. [114]

Did Rodin simply see the same curve in the crescent shape of this dancing body as in a lotus petal? Or did he associate the God and the lotus with their functions as creator and created world? Another comparison could be made, not between two cultures but rather between two arts. In fact, Rodin is certainly alluding to another artwork that was contemporary to his writing of "The Dance of Shiva": Claude Monet's *Water Lilies*, paintings created between 1885 and 1918. The two men shared a friendship. Rodin mentions this in an 1897 letter to Monet: "the same feeling of fraternity, the same love of art, we have become friends forever."[115] He mentions that they share the same "pursuit of nature." The painter invited the sculptor to enjoy the springtime weather with friends at Monet's gardens at Giverny.[116] Monet's quest to show the water lily from every angle—at every hour of the day, in every season— Rodin mirrored in his own way with his method of constantly walking around his models, as Goloubeff too had done when he walked around the Shiva bronzes to photograph them from so many different angles. Rodin writes eloquently about this:

> As new views appear when one moves about, so too does a masterpiece transform us, based on the movement that it provokes in our spirits.[117]

Another avenue for research is suggested by three drawings in which Rodin depicts a woman posing nude, lying on her back with her head raised, legs folded, feet resting on the ground and touching the thighs at the top. These drawings are annotated in his handwriting at the bottom right: "water lily - the birth of Venus"[118], "water lily - lotus"[119], and the third, "nenuphar" [water lily][120]. Presented in this way, the body effectively resembles the petals of this aquatic flower…but this is far removed from the god Shiva's posture! These women could be at the edge of what Rilke—then Rodin's secretary—called "erotic figures, not for exhibition", in the sense that they could no longer expect, due to excess of desire and indecency.[121] Certain drawings of Rodin's scandalised a segment of the public, who deemed the artist "crazy, brutishly and sensually crazy."[122] But Rodin was inspired by such feminine forms, as they manifested to him the unbreakable connection between creation and desire, ensuring the passage of one form to another:

> Whenever I have a beautiful female body for a model, the drawings that I make of it give me images of insects, flowers, fish. This seems implausible to me and I wouldn't have even suspected it myself.

If Monet invented methods of light diffraction to bring forth the appearance of the water lilies on his canvas, Rodin saw within the flower another mode of creation: that of a network of analogies. In this same frame of ideas, the chapter of *Cathedrals of France* dedicated to ornaments describes all sorts of fields of flowers he had come across since 1877 in regular trips across France to visit cathedrals. Here Rodin sees in a tulip "a bird, Gabriel's wing, a sunset, the gesture of Sappho, the gesture that provokes and that gives."[123] He goes even further in an erotic vision: "they throw themselves, they stretch out like happy courtesans," while certain ones are frightening, "with gold-striped blood, like flesh skinned alive, in full sunlight." Another is described "with the richness of Oriental silks, silks of Genoa."[124] In

the same spirit, he sculpted live models to understand "this flower of all flowers, the human flower."[125]

Thus, shall we see a water lily within the anthropomorphic dancing body of Shiva described by Rodin? If this is the case, such an endeavour moves in the opposite direction from that of *Cathedrals of France* in which the artist starts with a field of flowers in order to divine the essence of the human form. "The Dance of Shiva" invites us to contemplate the water lily within the sculpted body, or in other words, to find the principle of life despite the appearance of a pose frozen in bronze. Was this vision of Rodin's stimulated by certain encounters? We must not forget that this photograph of the bronze came from the trip to India undertaken by Victor Goloubeff, who must have recounted stories from this voyage to Rodin. It is the same with his drawings of the Cambodian dancers: to deepen his understanding of their art, Rodin met the dancers several times, and he even began making plans in 1906 to meet them in Cambodia, a dream that he never realised. Yet, although he had made 150 drawings of them, a great number of these drawings were not made of the dancers posing at Marseilles, but in his hotel room, the evening of their exposition and then over the course of the months and years that followed. Rodin cut the sheets of paper, rearranged the drawings and added gouache. Rilke, who was present at the exhibition of some of these drawings at the Bernheim-Jeune gallery in 1907, remarked upon the annotation "Human flowers" written upon one of the drawings:

> One thinks of flowers; of flowers from the herbarium where the less voluntary attributes of a flower are saved, specified, and frozen by drying. Dried flowers. Naturally, no sooner had I thought of this than I found noted in his happy handwriting, somewhere: "Human flowers." It is almost regrettable that he did not even make us work to find it: it is so evident.[126]

Even when Rodin relied upon his visual memory to draw a dance movement after having seen it, he did not dwell upon the disappearance of the live model. But he sought to bear witness to the passages of time in which one meets with indifference life and death, a model and the division of her

body into parts, lost tradition and its reconstruction. During a trip to Reims in February 1910, on a very small sheet catalogued in the Musée Rodin's archives for *The Cathedrals of France*, Rodin provides this reflection, handwritten above a sketch of the figure of Saint Georges:

> Do the Gods need new forms, updates upon man's great intelligence? Life among us is not significant, but life itself is sublime, religious. Like a poor sheet detached from a church book/ the greatest deference measured/ the dancer of Antiquity enters, quaking.

Recall in *The Cathedrals of France* how the art of the Middle Ages is marked by connection to Byzantine art in India and in China.[127] Rodin explains how the ornamentation of the capitals of cathedrals such as the one in Reims is based upon nature, with motifs of leaves and florets. In his view, this Middle Age art has a very defined character:

> It has penetrated the life of flowers by considering their forms, analyzing their joys and sorrows, their virtues and weaknesses: these are our sorrows and our virtues. And the flowers have given us the Cathedral. To be convinced, it is enough just to go to the countryside and open one's eyes. You will receive an architecture lesson with each step.[128]

These two texts, one on cathedrals and the other on the Shiva sculpted in bronze, have in common this interest for works belonging to the same historical period. We find these symbolic equivalencies between the God, the water lily and the lotus pedestal on one hand, and the flower, the cathedral, and the human flower on the other hand. These analogies enable us to better understand the importance of this feeling of overflowing that Rodin experienced before the Shiva bronze, as he describes at the very beginning of his text. Although he states in *Cathedrals of France*[129] that he is familiar with neither India nor China, but he loves the French countryside "with tenderness," his expression is the same whether standing before this Indian statue or facing impressive religious edifices in his own country. Not only have air, sun and water shaped his view as an artist, but these elements have

gone so far as to form the basis for the artwork itself. As the Shiva inspired the poetic image of an alliance among light, air, and the "flow of life", so it was in traversing the Loire countryside that he marvelled before "this river of light" illuminated unpredictably by "an irresolute sun"[130]:

> French cathedrals are born from French nature. It is the air of our sky, at once both light and gentle, that has given our artists their grace and refined their tastes (…) and the voluptuous range of light and shadow that gives rhythm to the entire edifice and compels it to live.[131]

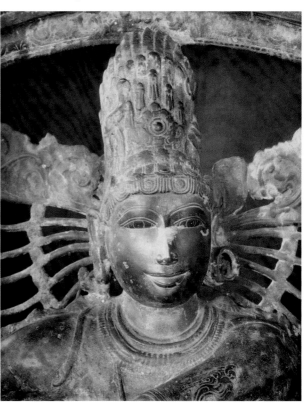

Nevertheless, the rich floral motif ornamenting the hairpiece of the Shiva bronzes (fig. 38) scarcely caught Rodin's attention, even though in his own body of work, we find a long list of analogies based upon flowers. However, the sculptor possessed in his personal collection a photograph of a straight profile of the head of the God, unpublished, in which the sinuous line of the serpent festooning the hairpiece appears clearly. We see how the diadem (*jatā-mukuṭa*), typically present on royal or divine figures, is made of jewels set in precious stones and of pearls, with motifs in the form of flowers. In the same review, E.B. Havell describes quite precisely this part of the Elephanta Shiva: "the hairpiece of the god is, additionally, adorned with a skull and various floral emblems of the Shivaist ritual, which include the tri-lobed leaves of the *bilya* tree (*crataeva religiosa*) and a branch of the *nirgundi* (*vitex trifolatia*)."[132]

(FIG. 38): Shiva's diadem, Rodin's collection

The further we advance in this web of analogies among Venus, the water lily, and the god Shiva, the more we transform our initial understanding

of "The Dance of Shiva". In the relationship he weaves with artworks of Antiquity, Rodin cites the "woman as a vase". His standing female nude, called *The Birth of Venus*, with a tubular vase (1895-1910)[133] is made of two incongruous elements: an antique vase, in which he has sculpted a female body with bent knees and the back angled forward. He describes his difficulty with drawing vases, up until the day when, in a female body, he found "a superb form of a vase, with real lines and harmonious relationships." He adds an essential remark:

> It is not about creation. Creation, improvisation, these are useless words. It is about understanding.[134]

Understanding, for Rodin, is synonymous with building. It is about building the connection between two heterogenous elements and then knocking them together, without preconception. The title of *The Birth of Venus* resonates with other paintings of the same name, all inspired by the ancient Greek model: the Venus Anadyomene. In Boticelli's *Venus* (1485), the shell replaces the vase and the goddess stands upright. The Venus by Cabanel (1893) is lasciviously lounging in the ocean. But all these forms of nudes are diametrically opposed to the "water lily" Venus drawn by Rodin. When Rodin drew his *Birth of Venus*, a living organism appeared, at the limit of human form, the head seemingly confused with the pelvis. When, in "The Dance of Shiva" text, Rodin connects the gesture of Venus' hands with those of Shiva, is he projecting this conception of a modest goddess upon this antiquity of India? Does he limit this symbolic equivalence between the hand of Venus covering her genitals and the raised thigh of the dancing god covering his own—which happen to be invisible upon his bronze body?

In his book *Ouvrir Vénus* (*Unlocking Venus*), Georges Didi-Huberman recalls the ambivalence of the Venus of Medici.[135] This goddess was clothed in three pieces of attire—literary, conceptual, and marble—so that "the symbolism of the nude could establish itself before the phenomenology of its nudity."[136] Thus, by an entire process created by the Renaissance for antiquarian forms "of contradictory intensities, of hybridizations and

instabilities," we have fabricated "of the nude itself the clothing, the garment, the stand-in for something else."[137] The presence of Venus in Rodin's text creates an interesting resonance with the feminine curves visible in the Hindu goddess sculptures he purchased in 1914. Among the wood panels he acquired in 1914, noteworthy is a magnificent sculpture[138] of Durgā, the consort of Shiva in form of warrior goddess. (Fig. 39)

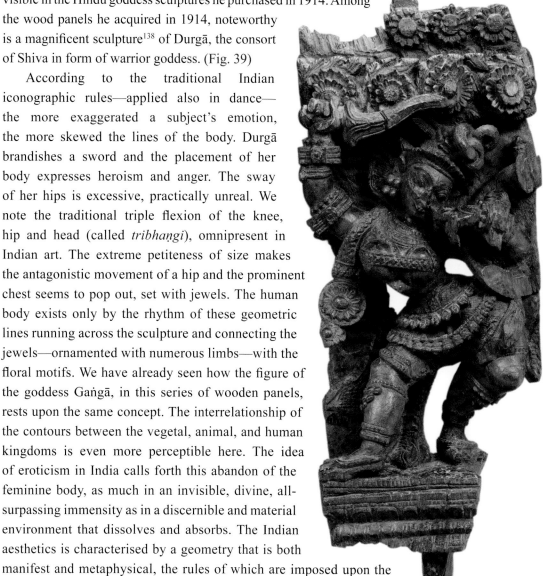

(Fig. 39): The goddess Durgā. Teak wood panel, Rodin's collection

According to the traditional Indian iconographic rules—applied also in dance—the more exaggerated a subject's emotion, the more skewed the lines of the body. Durgā brandishes a sword and the placement of her body expresses heroism and anger. The sway of her hips is excessive, practically unreal. We note the traditional triple flexion of the knee, hip and head (called *tribhaṅgi*), omnipresent in Indian art. The extreme petiteness of size makes the antagonistic movement of a hip and the prominent chest seems to pop out, set with jewels. The human body exists only by the rhythm of these geometric lines running across the sculpture and connecting the jewels—ornamented with numerous limbs—with the floral motifs. We have already seen how the figure of the goddess Gaṅgā, in this series of wooden panels, rests upon the same concept. The interrelationship of the contours between the vegetal, animal, and human kingdoms is even more perceptible here. The idea of eroticism in India calls forth this abandon of the feminine body, as much in an invisible, divine, all-surpassing immensity as in a discernible and material environment that dissolves and absorbs. The Indian aesthetics is characterised by a geometry that is both manifest and metaphysical, the rules of which are imposed upon the sculptor of such works, leaving no room for his own individual liberty;

these rules are emphasised in Rodin's text, as he contemplates the god of dance from an overall perspective: "as if divinely ordained, there is no intimation of revolt in this body: one feels that everything is in its place." On the back of one of the photographs that Goloubeff had given to him, Rodin scrawled a few fleeting impressions in pencil, with no punctuation: (Fig. 40)

(Fig. 40): Handwritten impressions by Rodin on the photograph of Shiva Naṭarāja

The sections where the limbs are
in the one are thus the formation
distance does not operate on whimsy
but on the rules which nature
obeys: that is to say that liberty
is nowhere, where then it is called
bad sculpture
The soul is the law even of truth
thus a dynamic law

WHERE IS THE ORIGINAL TEXT?

A complete manuscript of Rodin's text does not exist. Apart from a few phrases on the back of three photographs, we can find only a very partial copy of four excerpts from "The Dance of Shiva" in Rodin's thirty-sixth notebook. But these excerpts are not in the same order, and several words have been changed or deleted. The same is true for *Cathedrals of France*, for which only nine passages can be found. Below is a passage common to all three texts, but which Rodin introduces in a different way each time:

Notebook number 36

Woman kneeling, leaning to the side.
Kneeling, she joins her two hands together in prayer; they separate the breasts and the abdomen. This gesture can contend for grace, working with the gesture of the Venus of Medici who defends herself with her arms, as this one defends herself with prayer.
The intellectual woman, the ingenue prayer.
This one defends herself with a morbid prayer. Passion? The shadow over this beautiful body is inconceivable and her hands that touch the light imprint themselves upon this delicious fruit, which shadow hides and allows the eloquent mystery to be seen. If there had not been a model with depth, the contour could not

be fleshy, supple; it would be dry. This beautiful straight shadow of the woman on her knees, this direct shadow that separates the torso into two, leaving via the two thighs, one half in shadow, the other indeed chiaroscuro, one shadow projected, a shadowy lightness brings her to life. The pubis is hidden in this darkness.

Cathedrals of France[139]

(Woman kneeling, leaning to the side)
Her hands are joined in prayer; they separate the breasts and the abdomen.
This gesture could rival, in its grace, that of the Venus of Medici who hides the secrets of her beauty with her hands: this living being defends herself with this morbid prayer.
With such extraordinary passion does shadow embrace this beautiful body! The hands, touching the light, imprint themselves upon this delicious fruit, which is hidden by shadow but still perceivable, the eloquent mystery. Without the model in depth, the contour could not be as fleshy and supple as it is; it would be dry.
This beautiful straight shadow of this woman on her knees, this direct shadow that separates the torso in two, leaving via the two thighs, it grasps one halfway and the other completely: contradiction of this projected shadow and of this chiaroscuro, this one giving life to the other.

The Dance of Shiva

Viewing a profile of Shiva:
Admirable, these two hands that separate the breasts and the stomach. This posture could rival the grace of the Venus of Medici; as she shields her physical beauty with her arms, so appears Shiva, seeming to protect himself with this ingenious movement.

This right shadow that separates the torso into two parts, gliding down the length of the thighs, one in chiaroscuro, the other entirely in obscurity. The pubis cannot be seen, concealed in this obscurity …

From another profile of Shiva:
These two legs in differing lighting; each thigh casts a shadow upon the other leg.
If there were no interior model, the contour could never be so fluid and supple. It would be too dry with this direct shadow.

Based upon the facts that *Cathedrals of France* was published in 1914 and that the only date known for the writing of "The Dance of Shiva" is autumn 1913, it is probable that at least part of these two writing projects would have occurred simultaneously. In *Cathedrals of France*, to better understand the essence of the sculpture's connection to sacred architecture, Rodin suggests that the reader regard three feminine nudes: one lying down, the second lit from the side, and the third kneeling. He regards the first of them as a "morsel of living antiquity, with the same forms as in antiquity, stretched out upon the settee, admirable." What analogy does he establish in "The Dance of Shiva" between these two bodies, the female model and the God in bronze?

The pages of the petite notebook cited are undated and bear no mention of the Indian statue. A problem arises upon first reading: although these correspond, largely, to the passage within the *Ars Asiatica* text entitled "Viewing a profile of Shiva", the notes in the notebook have an entirely different title: "Woman kneeling, leaning to the side". Notably, the mention of prayer posture has been removed from this last paragraph. As for the joined hands resting against the chest—"this delicious fruit"—of the naked body, they have been replaced by the description of the posture of the bronze Shiva. There are numerous examples of such breaks, additions, and inversions of words. Indeed, the final sentence of the text describing "the eloquent head of Shiva" corresponds exactly to the sentence in the notebook in which he describes the face of the kneeling woman: "This

lovely lost profile indeed has its own profile, but where expression draws to a close and sinks deep, leaving the charm of cheeks curving down to join with the cords of the neck."

Slightly earlier in the Shiva text, the God's mouth and eyes are described exactly as Rodin described those of this woman. However, Rodin took care to replace the word "stone", which imprisons "the materiality of the soul", with the word "bronze"! The description of the lines of the face and those of the posture concealing the genitals are used in this way both for the female nude and for the sculpted Hindu god in bronze. This calls into question the very premise of our analyses, that the text for "The Dance of Shiva" was indeed inspired by the photographs of the Indian bronze! Thus we search in the Rodin archives of notes, sketches, drawings, and sculptures, for this image of the nude, praying woman. Indeed, several such drawings do exist, but these women are standing and some of them have their hands joined in front of their stomachs or lower abdomens. Those upon their knees are stretching their hands up, annotated "after prayer."[140]

Our research also uncovers several drawings of Cambodian dancers made by Rodin in 1906, in which the dancer takes a step with her hands joined.[141] One of them[142] includes a note in Rodin's handwriting: "Cambodian for the Glory, rejoins her two hands." This pose is analogous to that of *karaṇa 6, līna* "Erased"—"palms joined upon the chest, neck outstretched and leaning forward." This *karaṇa* is utilised by actor-dancers to express the traditional Hindu greeting, to welcome a loved one or to accompany any type of request. But Rodin writes here of a woman praying on her knees, not standing.

Between 1907 and 1913, added to the immense international success of his drawings of the Cambodian dancers in various exhibitions, Rodin continued re-working these artworks in response to a commission. The project encompassed a large decorative fresco in the former seminary of Saint-Sulpice. The venue was to serve as an exhibition space for the works of living artists, works then stored at the Musée du Luxembourg. The project was unfortunately abandoned in 1913 for lack of funds, the same time period that Rodin was writing his text on Shiva. However, it is interesting to note that as soon as he was commissioned, Rodin chose to

depict Paradise in the fresco, using these Cambodian figures. He gathered approximately twenty drawings, already noted *Cambodian for the Glory*. (Fig. 41) Those drawings cited above were to be included in this fresco.[143] The word "glory" comes from the vocabulary of Gothic art, corresponding to depictions of Christ in Majesty. In his book on the cathedrals[144], Rodin attributes this term to the angel as messenger between the ancient and modern, between what has passed and what is yet to come. Its living model, for Rodin, is the Cambodian (or Javanese) dancer, to whom in certain drawings he adds either a statuette or a crown held in one hand, to obtain "the perfect image of some unknown and ever new Victory."[145]

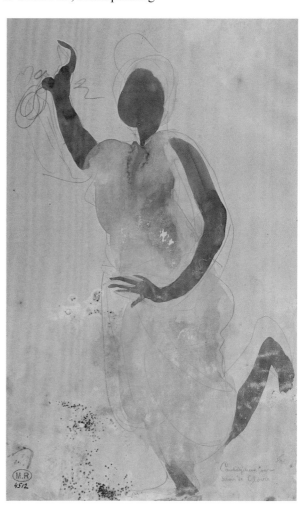

FIG. 41. *Cambodian for the Glory*, Rodin

Occasionally, the "wings" of the Cambodians' costumes are transformed into those of antiquarian Victories. In preparing this fresco, an equivalence was struck between the celestial beings and the Cambodian dancers on one hand, and between the dancing body and the naked body on the other.[146] He sought, in his words, to minimise the complex drape of their costumes to the line of the naked body. As such, one of his drawings of a costumed Cambodian dancer for the fresco[147] bore the annotation "Naked", and on the reverse side of this drawing[148], the dancer's silhouette appeared unclothed.[149]

Yet another new element may be added to this web of analogies among feminine beauty, the Cambodian dancers, the nude, and the god Shiva. The element of the cathedral looms large. At Beaugency, when Rodin tarried to watch young girls passing in the street or coming and going from the

religious structure, it was in order to arrive at the following conclusion: "the architecture of our cathedrals was necessary to the beauty of these women, like a grandiose and proportionate frame. In feeling thus respected, it is the place where the one who will be our living Victory may be born and developed."[150] In his eyes, the cathedral is "a magnificent eulogy to Woman," conceived throughout in the "plastic language of stone."[151] We have thus continued to search through the innumerable notebooks and scattered sheets of paper, seeking the drawing of the kneeling woman that could have inspired his text from Chapter 14 and where we could discover the deep analogy with the dancing Shiva described by the same text. A sentence from *Cathedrals of France* strengthens this concept:[152]

> Woman is the true Grail. She is never more beautiful than when kneeling; the Gothics thought the same. The exterior church is a kneeling woman.

A "testament" text?

At the age of 73, four years before his death, Rodin set about to writing this poetic text on Shiva Naṭarāja. In that same year of 1913 (fig. 42), his artwork was exhibited in Tokyo, at the first Roman Seccession, at the World's Fair in Ghent, and at the 11th International Exhibition in Munich. A room at the Metropolitan Museum in New York was dedicated to him, and on the occasion of the Armory Show, seven of his drawings were presented alongside works by Picasso, Brancusi, Matisse and Duchamp. Also in that year, Rodin traveled to London to oversee the installation of *Les Bourgeois de Calais* (*The Burghers of Calais*) in the Parliament gardens. A crucial text for understanding "The Dance of Shiva" is a non-commercial publication of Rodin's interviews with Dujardin-Beaumetz (who died in September 1913), a limited edition with only 500 copies intended for the families and friends of the two men. Also published that year was *Le Vrai Rodin* (*The Real Rodin*), a book by Gustave Coquiot, his former secretary.

Despite all this international success, in Rodin's letters to Hélène de Nostitz[153], whom he considered at that time to be his only friend, he often admitted to moods bordering on hopelessness. He underscored the daily

importance of the companionship represented by the antique statues in his studio. Fittingly, he exhibited his collection of antiques in Paris for the first time, at the Medical School. But the public showed little interest in the show.[154] His 1913 correspondence bears witness to the sculptor's physical exhaustion, to his own bronchitis as well as the asthma of his companion Rose Beuret[155], who was always close to him despite his innumerable female conquests. Rodin, who had recently split with Claire Coudert, duchess of Choiseul, frequented the Parisian "exotic" dance scene, at the time keen on the "Hindu numbers". The dancer Isadora Duncan asked him for several of the eight drawings he had made of her, to illustrate the programme of her production of Aeschylus' *Suppliants*, with performances planned at the Théâtre du Châtelet.[156] We return once more to Rodin's deep analogy between the two bodies: feminine and divine. In "The Dance of Shiva", when Rodin faces the full bronze, he writes:

> The posture is known among artists, but at the same time, it is uncommon; for in every pose there is nature, and such distance! There is indeed what some people do not see: the unknown depths, the depth of life.

(FIG. 42): Rodin working on the head of Lady Sackeville-West, 1913

Yet, in the chapter "*D'après nature*" ("According to Nature") in *Cathedrals of France*, he writes almost exactly the same thing. However, these words are emitted in the marvel provoked by a woman disrobing:

> At first sight of the body, the overall view, shock, commotion.
> Like an arrow, a moment of surprise, the eye moves again.
> In every model there is the fullness of nature, and the eye that knows how to see discovers and follows it, quite a distance! Indeed, there lies what most do not know how to see: the unknown depths, the depths of life.[157]

Cathedrals of France includes 14 chapters. The final chapter has no title and comprises five successive themes: "According to Nature, Architecture, The Mass, Sculpture, and The Mouldings". These phrases are also found in "The Dance of Shiva", in the first section. Upon consultation of the five pre-press typeset proofs of *Cathedrals of France* corrected by the publisher and stored in the Musée Rodin archives, we remark that these proofs are all missing the 14th chapter. This chapter was thus added at the last minute, without the publisher's edits and corrections. Its presence, however, proves to be essential, as Rodin writes in the first lines of the chapter:

> It is in my last minutes that I speak, to reanimate and call forth the past centuries. I am like breath in a bugle, amplifying the sound.
> I resign myself to the death of these edifices as I do to my own passing.
> Here I make my testament.

In the book's first pages, the publisher warns readers of the disorganised character of Rodin's "notes", taken "from day to day, at random during his periodic visits to the Cathedrals," detailing his observations and impelling his admiration. Should we imagine Rodin undertaking some of these pilgrimages while he was writing the text on Shiva? The position of this 14th chapter at the end of the book is troubling: does the "testament" only include the twenty pages comprising this chapter? Were any of these phrases inspired by the Shiva bronzes, nude and decorated? Why

does this chapter begin with the sculptor marvelling at a female model as she undresses before him? He has just described the fields of flowers, those that women offer in full sunlight. And just after this few solemn sentences, he bequeaths to posterity the following golden rule of his aesthetic vision:

> Prodigious beauty covers all, like a fabric, like an aegis. There is no chaos in the human body, model of all, beginning and end of all.

Once more in these few lines, the book on the cathedrals resonates with a passage from "The Dance of Shiva":

> These hints of perfection! The mist of the body! As if divinely ordained, there is no intimation of revolt in this body: one feels that everything is in its place. We see the rotation of the arm even at rest by examining the shoulder blade, how it protrudes, the rib cage, the admirable attachment of the ribs holding the shoulder blade in place, ready to move.

The body as Cathedral, the Indian body

For Rodin, "dance is animated architecture."[158] In his book on the cathedrals, he makes several allusions to Indian art, directly and indirectly. First, he dedicated the first page of his book to a description of the image of a man in equilibrium upon which the construction of a cathedral can be based:

> Everyone knows that the human body, in movement, becomes unbalanced and that equilibrium is reestablished through compensations. The weight-bearing leg, returning under the body, is only the pivot of the full body and it makes, in that moment, the unique and total effort. The leg that does not bear weight serves only to modulate the degrees of position, to modify, be it as slowly or rapidly as necessary, until it substitutes itself in order to liberate the weight-bearing leg. (...) These compensated cantilevers, these perpetual and unconscious motions of life, explain to us the very principle that the architects of the flying buttress have applied.

The plausible connection with the bronze of the god of dance that he was studying at the same period, is established because Shiva performs this double movement of one leg crushing with full force the demon of the darkness while the other is raised with a grace, free of earthly gravity. Written on a small piece of paper conserved in the museum archives[159] and dated 1914, Rodin expresses the same concept in another way:

> The human body standing upright is the Greek column perpendicular to its base. When we place our weight on just one leg, it is the cantilever of Gothic architecture that exists in the movement. In each of our movements, this cantilever is produced, compensated by an opposing mass. The Gothics seem to have taken from man or women the appeal of such equilibria.

The same emotion fills him one night before the Cathedral of Reims:[160]

> These guardians of shadow over the door, for eternity, these great witnesses, this honor guard in three rows - by four, by six, by ten, these saints: one could say these who have risen from the dead, standing over their tombs.
>
> My heart beats faster in the presence of these strange figures, a spirit that is not of our world. What terrible enigma they bring to me! They seem to bring forth a testimony. They live a life of centuries. Are they apparitions? They have a formidable religious intensity. Perhaps they await some serious event: they are planning. They are no longer of the times that saw their sculpting, their appearance changes constantly, and these figures have, for me, a particular new and foreign accent: I think of Hindustan, of Cambodia …

Dance, a "chaos seeking rhythm"

Over the course of this research, we have been able to remark at how dance invites the human body to move beyond its morphological limits. This process is suggested by the function of the god Shiva, both in the Hindu pantheon and in Rodin's text. The artist's poetic approach suggests apt parallels between the Hindu symbolism, foreign to his own culture, and his

idea that a sculpture must in essence be dancing. In the poetry of his text, Rodin names the potential transformations of a dancing body. But in the body of his work as a sculptor and artist, even when certain organic parts are missing, the human body always resembles a human body—as opposed to the dance oeuvre of Loïe Fuller, whose contortions and movements could evoke butterfly wings, a medusa or a fountain. When Rodin entitled one of his nude drawings *Water Lily* (*Nymphéa*), the female body is still visible, the flower only suggested by the body's portrayal. In "The Dance of Shiva", the rhythm of transformation—for example, at the mouth of a volcano or at the mouth of a serpent—assumes no equivalence between the semantic sense of the word and the meaning of the bodily movement, as the author describes neither the God's dance nor its godly attributes, nor does he connect with the gestural codes, with the hand that might take, for example, the form of a cobra head (*mudrā sirpa-śīrṣa*).

How can we thus explain such a process? The text volleys the reader between two feelings of being, between that of expansion and that of withdrawal into the self. On one hand, as early as the first fragment of "The Dance of Shiva", we find a sense of "overflow" found by Rodin in his perception of Shivaistic art, and more broadly of the art of the Far East, at once as an escape from human corporal limits as well as a transgression of known cultural boundaries. On the other hand, the text speaks to us of an abrupt and unforeseen contraction, that of a muscle "ready to burst into movement" according to the play of light and shadow. Rodin's experience of strangeness, of foreignness in the face of this Asiatic aesthetics is inseparable from his experience in contemplating this mysterious bronze, animated down to the smallest details. "The Dance of Shiva" is a remarkable text in that at no moment can the reader believe that Eastern art held any particular influence over Rodin's sculpture, nor can one trust in a simplistic ethnocentric projection of his Western view on such a millennial art form. In his work, the artist sought above all "the immense Unknowable" and "all that dives into an infinite obscurity."[161] Such original poetic interplay between the sculptor's creative thinking and the symbol's cosmic dimension inspired a letter by the poet Rainer Maria Rilke. He writes to Rodin after spending some time with him at the Hôtel

Biron to contemplate his sculptures, which he compared to "globes", to "constellations" or to "unforgettable stars of fatal flame." He terms the drawings of the Cambodian dancers from 1906, "Pleiades" (a constellation of stars). He calls the draft artworks in the atelier "stars" to discover and to love, but overall, to express rhythmically:

> And as all these beings become infinitely clearer in a moment of eternity and take place in a celestial equilibrium between music and geometry (one would say), where there would still be - as these places are immense - a chaos seeking rhythm.[162]

At its core, the balance of the god Shiva dancing upon one foot maintains an organic tension between a chaotic, shadowy environment and an orderly, luminous world. It resonates with Rodin's inspirations, which "have always oscillated between Phideas and Michelangelo" between "balance and calm" and "suffering".[163] Indeed, in his exchanges with Paul Gsell, Rodin specifies that he leans more towards serenity, a concept that he also uses in describing Shiva. Curiously, the wooden sculptures of Shiva that he purchased in 1914, originating from a temple in Southern India, do not express this beatitude. Rather, as we have described earlier, the statues express a sense of destructive anger and romantic jealousy. Recall that one of these wooden sculptures shows Shiva seated tall in his yogi pose, using his third eye to burn Kāma, the god of love, who has come to bother him. Another of these sculptures shows Shiva raising one leg straight up, in the midst of a love spat with his paramour, who has taken on the terrifying form of the goddess Kālī.[164] This pair of contradictory views of Shiva is examined in "La Trimurti d'Elephanta", E.B. Havell's article in *Ars Asiatica*, when he describes one of the inner surfaces of the temple:

> Shiva seems to be vibrating the rock to the rhythm of his dance…this dance is the symbol of cosmic rhythm - of the material force whose momentum sets the universe into movement and finishes by dissolving it. On the other panel, the same god, appearing as an ascetic lost in contemplation, represents the power of abstract thought that watches over all creation.

Dance movements, collages of drawings

Rodin often maintained measures of ambiguity and ambivalence when it came to the meaning of bodily movements. In his collage of two drawings, entitled *Couple féminin*[165] (fig. 43), he juxtaposes two figures: the first, a standing body, balanced on one leg, with chest stretched towards the heavens (in an acrobatic posture analogous to that of *karaṇa* 50 and similar to "Element A" (*Dance movements*), and the second, a woman lying on her side. In effect, Rodin took one of his drawings, showing a dancer with one leg lifted high behind her, and upon it he attached the drawing of a woman lying down, presumably removed from some other medium or notebook. Together, this pairing gives the impression that both bodies are resting flat, horizontally, one against the other. In this way, dance would show a necessary alliance or alternation between muscle mastery and relaxation, between technical prowess and rest, between a spine lifted vertically and one coiled up upon the bare ground.

Such collages permit a movement to change meaning, identity, even cultural origins. This drawing resonates with the text of "The Dance of Shiva", which also refuses to be placed into a horizontal timeline, the history of a culturally codified narration, and which runs counter to the movements of a bare body whose meanings remain unknown and foreign to a Western eye. It is a bit like Mata Hari, who is said to have danced nude: she removed her veils one by one, on 15 March 1905, before Émile Guimet and his guests[166], before the bronze Shiva mounted in the Musée Guimet library. She removed her veils to reveal her nudity: but what nudity? Her chest was covered with an ornate satin brassiere encrusted

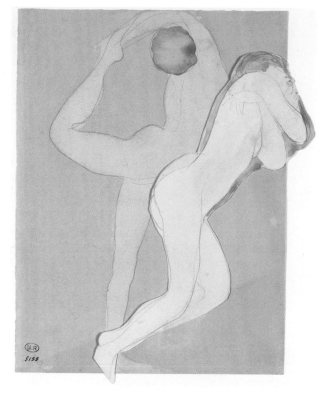

(Fig. 43): *Couple féminin*, Rodin

with stones, while a flesh-colored stocking covered her body, from her feet to her bust. In sync with the sculptor's vision, eroticism cultivated this interplay of veiling and unveiling, ever kindling desire.

Let us return to this collage, the *Couple féminin*. The ambivalence of prone and standing bodies is of the same order as the ambiguity in the poetic fragments that comprise "The Dance of Shiva". Based on *Cathedrals of France*, one of the bodies posing nude is lying down, yet Rodin describes the figure with the same words as those used for the divine dancer balanced perfectly upon one leg. Recall that in the text on Shiva, the reader sees a masculine, standing body, while in *Cathedrals*, one can distinguish three feminine figures—lying down, lit from the side, and kneeling—and finally in Notebook 36, the nude woman seems to move several times in order to finally fall asleep:

> Her arms pulled back, she seems overcome, shortening the eyes, nose, cheek, mouth, a circular line more or less concentrated. All things shown by a sleeping bust.

As for the nude stretched out on a settee, "a morsel of living antiquity", *Cathedrals of France* discusses this figure for a bit longer than the other two, insisting upon the sleeping image:[167]

> Somnolent flesh, tranquil lake.
> The middle of the sea where zealous vibrations disappear
> Ample, white flesh.

The sleeping woman in the *Couple féminin*, given all evidence, is connected with this text, as with Rodin's drawings, or sculptures, that marry movements with their opposite counterparts.[168] The same body can at once suggest both flight and fall. The titles for these drawings form a semantic web often associated with celestial order among the world of the flesh: *L'ange gardien* (*The Guardian Angel*)[169] becomes *Danaé* when Rodin turns him 180 degrees, while his *Vulcain* (*Vulcan*) is the inverse of *Icare* (*Icarus*)[170]. In such metamorphic reversals, an effect of weightlessness

is often observed. It may be created by the addition of veils, wings, and raised arms, or by cut-outs and collage of figures upon a completely blank surface.[171] The absence of environment eliminates the concept of gravity upon the human body, even in the case of the acrobatic equilibrium in *Couple féminin*. Such female flesh, "ample" and "white", pervades the full space: the sheet of drawing paper itself takes shape. These drawings imply a choreography, a certain writing of movements in which the spectator seeks out signs, hoping to reconstitute a path that is as much physical and graphic as literary, moving in an arborescent, non-linear structure invited by this type of assemblage.

(FIG. 44): Face of one of the two Shiva bronzes studied by Rodin

A final example of image reversal is when Rodin describes Shiva's eyes in his text, he seems to attempt to be faithful to the corresponding photograph (Fig. 44), in which the dancing god holds his head erect. But, at the beginning of Chapter 14 of *Cathedrals of France*, it is evident that the character in question is lying down. Justly, two sentences have been removed from the Shiva text, as they specify that this woman poses with her head tilted back! We transcribe these lines again below, italicising the first line, which is also present in *"The Dance of Shiva"*. And a final detail that shows the incessant and ever-changing interplay of Rodin's references: to describe the mouth of the Hindu god, Rodin compares it to the undulation of a serpent, while in the *Cathedrals* text, such movement belongs to an "ancient dolphin"!

The eyes that have but one place to hide are made of the purity of line, of the tranquility of stars.
Like a fallen fruit, this reversed

figure, with the horizontal eye that hardly sees, but that reveals itself, that calls …

All these curves speak, always repeating the same gentleness, organizing the expression of an infinite world: but this eye, like a sun of intelligence and love, gives life, never withholding it. - However, this eye and this mouth quite understand each other.

From this erotic primer on the *Couple féminin* and the figure reversal process, we return, finally, to the figure of Psyche. Though present in the texts of Notebook 36 and *Cathedrals of France*, she has been erased from the text on Shiva, at the moment when Rodin describes the front view with its "garlands of shadows". While the *Cathedrals* text replaces the word "serenity" with "truth" and prefers to discuss "luminous traits that describe", the notebook text reveals a more erotic character, in the line where Rodin would have sketched upon the blank page while contemplating his model:

In the shadow there are twilights that give shape, but with such serenity! The grace of the voluptuous Psyche is privileged here. Indeed, upon the line of the contour I see a stroke of light that flows over the side of the torso and the thigh.

Treble form, treble duvet. This swollen line is filled with its roundness, its clarity.

The *Metamorphoses* of Apuleius[172] describes for the first time the complete tale of the myth of Psyche. This king's daughter of irresistible beauty falls into a deep sleep after inhaling from a flask that she brought back from hell to give to Aphrodite, who takes her as a slave, out of jealousy. Psyche is awoken by one of Cupid's arrows. By marrying her, Cupid makes her an immortal. Earlier in this study, we have seen how Rodin titled certain drawings of the Cambodian dancers *Psyche*, mixing the posture of flight in these celestial figures with the suggestion of nudity.[173] In the same manner, *Couple féminin* brings together positions of the body—the ethereal step of Shiva (*karaṇa* 50) and a sleeping goddess. Was

Rodin thinking of these so-called "exotic" dancers who sought to prove the authenticity of their Hindu dances on Parisian stages, swooning in rapture to the point of breathless collapse? There was also Caro Cambell, nicknamed "the sleeping dancer". Appearing in 1920 at the Paris Salon d'Automne, she enthusiastically gave herself over to the music, to the point of being hypnotised, and then improvised her dance movements. In 1924, she received an enthusiastic response at the Comédie des Champs Élysées for her dance interpretations of Ravel's *Asia* and Debussy's *The Sunken Cathedral*.[174] The dancer Djiska also performed incantations on stage, attaining a state of trance in which she claimed to remember dances learned "440 years ago in an Indian palace."[175]

The acrobatic pose of the *Couple féminin* can be compared with another similar pose, seen from the back.[176] It is entitled simply *Psyche*! The pose is similar to that of "Element A" of *Dance Movements*, with the difference that only one hand holds the foot lifted head-high behind the body, while the other hand leans upon an undefined surface. The body has a rather androgynous appearance. This collage thus unites Rodin's female model with the suggestion of Shiva in one of his *karaṇa*.

The position of the heads is unrealistic. Covered with short chestnut hair, the dancer's head is lifted but also seems turned to the left side—although in such an acrobatic movement, this neck rotation is physically impossible; the neck can only be stretched back. As for the facial profile of the figure lying down, it gives shape to the grey traces of decoupage outside the line of the white body with the continuity of a long lock of brown hair, reaching to the groin, in the hollow of the back and on the side of the sheet of paper. The two arms folded under the head rest in part upon this background of dark hair.

We might consider that the drawing lacks alignment or was not properly thought through. However, this gap enables us to consider the process of collages as that of a dance, in several phases. Without a doubt, the acrobatic pose preceded the other—resonating with the antique, original character of the statue of Shiva—and then the paper with grey background was cut and attached to a darker sheet, wider and off-center, suggesting a potential movement and an imbalance. Finally, Rodin placed

a cut-out body intimately connected with the pelvis of the other, but sufficiently overlapping the white surroundings that we could imagine, in this instability, another movement. Once again, we find the active role of chiaroscuro, transferred here from the bodies to the luminous matter that surrounds and carries them. Rodin captures here what he termed, while contemplating the "sacred body" of the Venus de Milo, the "orchestras of shadows":

> They surround beauty with mystery, they pacify us and permit us to listen undisturbed to this eloquence of the flesh, which matures, which amplifies the spirit.[177]

Camille Claudel's Shiva

Our analysis of "The Dance of Shiva" concludes with a consideration of the work of Camille Claudel. During the period that Rodin was preparing this text, on 10 March 1913, Camille Claudel was interned at the Maison de santé de Ville-Evrard, a psychiatric asylum. One of her artworks was entitled *Çakuntala.* Although they were separated at the time, Rodin tried in vain to convince the government to underwrite a marble version of this sculpture of Claudel's that had won the Prix du Salon in 1888.

Çakuntala is the name of a heroine whose romantic life is often included in Indian choreographies and stagings. Towards the end of the fourth century, the famous poet of India, Kālidāsa, took the heroine as inspiration for one of his most beautiful writings, whose verse begins and ends with an invocation to the god Shiva, beseeching his blessing.[178] The theme of the play concerns separation in love. The play celebrates the memory of happy love, as the young woman waits seven years for the return of her spouse. Camille Claudel began to sculpt this couple in 1888, the year when she began to share a studio[179] with Rodin; the latter was at the time working on *Le Baiser* (*The Kiss*), a public commission for the 1889 World's Fair. *Çakuntala* was first created in plaster cast, then in marble in 1903 (named *Vertunne et Pomone*), before becoming *L'abandon*, a bronze in 1905, and finally *Niohide blessée* in 1906. Camille showed this first monumental piece when she was 24 years old, and the

Salon des artistes Français awarded her with honorable mention. In all of the sculptures just cited, the attitudes and positions of the lovers remain the same: the king is kneeling at the feet of the young Çakuntala as they tenderly embrace. This scene corresponds to the denouement of the play, when the king begs forgiveness from his beloved, at the moment when he recovers his memory and suddenly recalls his beloved and the child that she raised alone.[180]

There is an intimate, subjective connection woven by Camille Claudel between the successive sculptures of Çakuntala and the fact that this story took place under the auspicious regard of the god Shiva. In Rodin's case, "the depths of life" revealed to him by the Shiva Naṭarāja may also suggest an autobiographical reference. As evidenced by the 1913 correspondence discussed earlier, marked with bitterness, the sculptor-artist aspired at the end of his life to taste ancient serenity, in the image of this Hindu god of dance. As for Camille Claudel, she would never cease to suffer from Çakuntala's separation with no denouement possible.

CONCLUSION

The texts by Rodin that explore his vision of India carry no autobiographical elements. In the 14th chapter of *Cathedrals of France*, his message on the quest for ideal beauty is addressed to an anonymous, impersonal audience. He thus offers up his testament to future generations of young women. As for the women who posed for him, their drawn or imagined bodies were sometimes symbolically cut apart and transformed. The drawings of the Cambodian dancers bear witness to this phenomenon. This process of creativity—by fragmenting a body, then reassembling or collaging the parts—reveals a surprising vision in which sculpture and drawing take their meaning from reliance upon another art: dance, as an arrangement of poses and steps then unknown in Europe, at times physically impossible, detached from their cultural context, diverted from their initial codes, transposed or invented. Rodin's poetic text also proceeds like a dismembered body, to the point of losing the idea of the original manuscript, as the words repeat in different sequences on a loose sheet of

paper, in a notebook, in an article or in a book. Even the identity of the dancing body tends to be erased, since the writing is almost identical in its descriptions of a woman posing nude, of photographs of a millennium-old bronze, of a Cambodian dancer or of a cathedral angel. Why do we observe such resonances, such fusion between the body of the god of dance and that of a female model? And how can we speak of an original model at a time when the so-called "Hindu" dancers effectively invented timeless tradition and a heroine's destiny for themselves?

Rodin's text has, until this point, itself been lost among artistic genres: Is dance the medium that sculpts a series of ephemeral poses? Or rather does sculpture suggest the deployment, retreat or elimination of a choreography? How can the body of a dancer god with perfectly geometrical, continuous lines be reduced to a poem made only of fragments? Is it to say that dance is an art form that does not belong only to one culture, only to one era? However, Rodin is distanced from the concept of a universality that encompasses cultural differences. Dance signals towards the unknown, towards a bodily metamorphosis, toward an infinite "overflowing"—according to the first fragment of "The Dance of Shiva", and as evidenced by a few unfinished phrases scrawled in pencil on the back of three of Goloubeff's snapshots. In *Cathedrals of France*, Rodin maintained this rhythm of scattered notes, leaving open the poetic meaning of his testament, a hymn close to that of Shivaism. The appeal of the body's transformation suggests the destructive force of the Hindu god as much as the hidden beauty present in every woman.

As mentioned, Rodin's text in *Ars Asiatica III* was juxtaposed with an article by Ananda Coomaraswamy, then a curator at the Museum of Fine Arts in Boston. One year later, in 1922, Coomaraswamy would publish a book in English entitled *The Dance of Shiva*.[181.] By 1913, Coomaraswamy had already published several studies on Indian art, including *Arts and Crafts of India and Ceylan*. Nevertheless, *The Dance of Shiva* described by this well-known Indian philosopher is antipodal to Rodin's text, based upon a detailed analysis of symbolic attributes and mixing references to Shivaistic myths with citations from Indian poems. It affirms, however, that this figure of the dance god, Shiva, offers to all "his rhythmic beat as

the source of all movement in the cosmos", "a response to the enigma of life" and "a theory of nature."[182]

A question remains as to the concept of this same divine figure in the text of Rodin: such a conception is quite distanced from the Indian aesthetic ideas according to which the sculpture was constructed, *a priori*; according to collective millennial and religious guidelines, enabling the viewer of the sculpture to receive the vision of the God. We have seen how Rodin sought, quite on the contrary, to deconstruct the sculpture from multiple points of view. Does this pose the question of the universality of this dance? Why did he systematically refuse religious symbolism? Was it in order to invent a personal poetic pathway between the parts of the divine body and their anthropomorphic forms, flouting the codified Indian iconography? He visualized Shiva's movements as the result of twists and turns of light and shadow, permitting each of his written fragments to slide behind the previous, without narrative sense. Rodin would have been able to decompose this god into a succession of poses, based on the chronophotography of Etienne-Jules Marey[183], exploring the cracks of its graphical curves in the style of kinetography, like the ninety photographs made of a movement from Loïe Fuller's *La Danse serpentine*[184]! However, the starting point for "The Dance of Shiva" was imposed by Victor Goloubeff's photographs, taken in a static form. Perhaps Rodin was missing but one thing from "The Dance of Shiva": an Indian dancer, interpreting and providing commentary upon the rhythmic variations of this pose.[185] Without a doubt, the Cambodians had served as a starting point for this, as his drawings show.

The staging of his live models like those of Antiquity rested upon the interplay of light, of near and far. The presence of shadow suggests the unfinished, moves us towards the infinite nature of interpretations and towards the impossible physical possession and intellectual mastery of the subject under study. We have seen the extent to which the constantly changing movement of light oriented Rodin's poetic vision. According to Gustave Geoffroy, Rodin enjoyed viewing his works "under the open sky" and would place his plaster casts in his garden or in the courtyard of his studio for several weeks in order to observe the diversity of the natural light. Viewing this bronze of Shiva, the sculptor seems to have behaved in

the same manner, as he let the hours of the day unspool before him, to open up to a poetic vision:

> Art exists only in the interplay of opposites. Light that plays with shadow, or the inverse.[186]

From "The Dance of Shiva", we retain a communion of thought between Rodin and this "Antiquity" of India: the idea of a total art, summoning the musical rhythm of percussion, poetic lyrics, architecture, sculpture, photography, theatre, and dance. The Indian tradition has chosen the image of the circle of fire, *alātācakra*, as one that surrounds the dancing god, to bear witness to the dazzling sight of such a complete art. The illusion created by the performance causes the spectator to forget the juxtaposition of these heterogenous elements—the different arts, different languages, different eras—by creating a continuum that delights the spirit as much as the senses. Whirling around like a firebrand burning in space, the process of creation is a divinely beautiful dance, as seen by the aesthete or the Hindu artist, or by Rodin, revolving around his model.

Endnotes

1. Out of the 27 photographs that Rodin received from Goloubeff, 15 photographs correspond to the first bronze and 12 to the second, numbers 16461 to 16487. Ten of these correspond to the ten photographic plates published in *Ars Asiatica III, Etudes et documents publiés sous la direction de Victor Goloubeff, Sculptures çivaïtes par Auguste Rodin, Ananda Coomaraswamy, E.B Hawell et V. Goloubeff* [*Ars Asiatica III, Studies and documents published under the direction of Victor Goloubeff, Shivaist sculptures by Auguste Rodin, Ananda Coomaraswamy, E.B Hawell and V. Goloubeff*] (Brussels and Paris: National Bookstore of Art and History [Librairie National d'art et d'histoire], G. Van Oest and Company, 1921). Two are missing in the current collection of the Musée Rodin, most likely to have been lost: one corresponding to Plate II, a profile of the first bronze. One photograph of Rodin's collection remains, however, showing the left profile of the same bronze. Plate VI, a close-up of the two hands closest to the body, is missing in the collection; however, the collection does include the same type of close-up of these hands taken of other bronze statues. Here are the connections between the published plates and the photographs in Rodin's collection: Plate I (Ph. 16464), Plate III (ph. 16462),

Plate IV (ph. 16463), Plate V (ph. 16465), Plate VII (ph. 16466), Plate VIII (ph. 16467), Plate IX (ph. 16468), Plate X (ph. 16469), Plate XII (ph. 16472).

2. *Ind. ant.*, 1872, p. 194.

3. On a postcard addressed to Auguste Rodin and mailed 6 February 1911, from Calcutta, Victor Goloubeff writes that he is about to mail Rodin that very morning a series of photographs, which should be received in six weeks and that Rodin will "certainly" like. Goloubeff adds, "We'll return with ten volumes of photographic documentation. I will be happy to know your thoughts on them, how you like the sculptures of the Indies and the old Buddhist frescos." Based upon two undated letters from Goloubeff, written sometime between his 1911 return from India and Rodin's writing of "The Dance of Shiva" in autumn 1913, we know of two important meetings that took place regarding the *Ars Asiatica* review. In the first letter, Victor Goloubeff is pleased that the sculptor has given to the publisher, Mr Van Oest, his agreement to write a preface to "our bibliographic volume on Oriental art, which will include a detailed reproduction of the Hindu bronzes from Madras." He then asks Rodin for a short interview for the following week, in order to give him the photographs selected for the publication and a print draft that would be made for him. There is also a letter written on a Wednesday, in which Goloubeff reminds Rodin of his "great generosity in promising a preface on the Hindu bronzes to *Ars Asiatica*" and suggests that they meet in his home on rue de Varenne that Friday afternoon, accompanied by René Jean, the editorial board's secretary.

4. According to an article by René Jean in the January 1914 issue of *La chronique des arts et de la curiosité* [*The Chronicle of Arts and Curiosity*].

5. Concerns *Indian Sculpture and Painting,* dating from 1908 and which the author mentions in his same bibliographic notes for *Ars Asiatica III*, (Brussels and Paris: National Bookstore of Art and History [Librairie National d'art et d'histoire], G. Van Oest and Company, 1921), p 28.

6. Yet an article by Victor Goloubeff focused on this same temple, in *Ars Asiatica III* (Brussels and Paris: National Bookstore of Art and History [Librairie National d'art et d'histoire], G. Van Oest and Company, 1921). Entitled "Ganga's descent to Earth," illustrated by 10 photographs that he had brought back from his 1910-1911 voyage in India. This was the result of a long research collaboration between 1913 and 1914, with "one of the best-documented expert of Dravidian art," Mr Jouveau-Dubreuil, who was at that time preparing the publication of *L'archéologie du Sud de l'Inde* [*Southern Indian Archeology*], volume 25, in the annals of the Musée Guimet.

7. Among the aesthetic and philanthropic friends who may have deepened Rodin's knowledge of Indian art, the famous banker Albert Khan organised voyages around the world and in the Far East in 1909. On Thursday, 27 May, of that year, he sent Rodin an invitation for a public showing of "several animated views" of his last voyage, held in the Charras room, to which he also invited the Members of the

Council of the University of Paris (see *Correspondance d'Albert Kahn avec Rodin*, Musée Rodin archives).

8. However, there were numerous variations, indexed in the treatises on Indian sculpture. There were seven for *Kāranāgama*, nine for the *Shilparatna* and eighteen for the *Kashyapashilpa*. This detail is cited in S.K. Ramachandra Rao, *Pratima-Kosha, Encyclopaedia of Indian Iconography*, vol. I, (Bangalore: Kalpatharu Research Academy Publication, 1988), p. 132.

9. Performed by a *bharatanāṭyam* actor-dancer, these two attributes are shown with two hand positions: *alapadma* for fire, with the fingers outstretched and separated like a fan, and *mriga-sirsa* for the drum, with the thumb, middle and ring finger joined at the tips while the index and little finger are reaching up, curved.

10. Excerpt from *L'Ishvaragîtâ*, vol. v, (Paris: Geuthner, 1933), pp.10–11.

11. These interviews were compiled by Augustin de Butler and published in *Éclairs de pensée: écrits et entretiens dur l'art* [*Flashes of thought: Writings and Interviews*] (Paris: Editions Olbia, 1998).

12. The first written references to *apasmāra* come later than iconographic references and identify him as *mūyalagan,* the demon of ignorance. While the character is practically nonexistent in northern and eastern India, he is represented for the first time in the South at Kacnipuram (eighth-century Mukteshvara Temple), as the incarnation of obscurity, confusion, and self-illusion. The demon dwarf is present in three forms of Shiva: *naṭarāja, ānanda-tāndava* and *ūrdhva-tāndava.* He has a tormented face, turned toward the god's right, the body of a small child or a dwarf, arms and ankles decorated with bracelets, with the waist and hips covered in laces. One of his hands is lightly raised, making the serpent's gesture. See Anne-Marie Gaston, *Śiva in Dance, Myth and Iconography* (Delhi: Oxford University Press, 1982), pp. 130, 232.

13. Literary tests describe this starting in the sixth century, in the *Tirumantiram* by Tirumūlar. The first bronzes with this posture date from the beginning of the Chola period, around 850 BC, and its golden age was between 955 and 907 BC, under the reign of Parântaka. The Chola kings, followers of Shivaism, oversaw the construction of a great number of temples dedicated to Shiva between 1279 and 880 BC.

14. Anonymous, "Le clou de l'exposition" ["The Highlight of the Exhibition"], *La Presse*, October 13, 1900.

15. Musée Rodin collection

16. Charles S. Heymans, *La vraie Mata Hari: courtisane et espionne* [*The real Mata Hari: Courtesan and Spy*] (Paris: Editions Promethee, 1930), p. 89.

17. Cited in Sam Waagenaar, *Mata Hari ou la danse macabre* [*Mata Hari or the Macabre Dance*] (Fayard, 1985), p. 85.

18. Musée Guimet, 18529.

19. For the famous Naṭarāja exhibited at the Musée Guimet and dating from the 11th century—like those in Goloubeff's photographs—arrived onsite only in 1928.

20. Katia Légeret, *Esthétique de la danse sacrée* [*Aesthetics of Sacred Dance*] (Paris: P. Geuthner, 2001), p. 33.

21. The term "nautch" is the Anglicised version of the word for dance in Hindu, Urdu, or Prakrit.

22. Christina L. Schlundt, "The Professional Appearances of Ruth St. Denis & Ted Shawn: a Chronology and an Index of Dances, 1906–1932," in *The Bulletin of the New Yord Public Library* (New York: New York Public Library, 1962), pp. 120–140.

23. Suzanne Shelton, *Ruth Saint-Denis, a Biography of Divine Dancer* (Austin: University of Texas Press, 1981).

24. Drawing cited, Inv. 5695. See letter from Constance Smedley to Ruth Saint-Denis, dated 31 October 1908, cited by Hélène Pinet in her book *Ornement de la durée* [*Lasting Ornament*] (Paris: Musée Rodin, 1987), pp. 16–17. She also visited his friends while on tour in Germany, including the director of the Weimar museum and two of his models—Ms Potter-Palmer and Hélène de Nostitz.

25. The *Washington D.C.* of October 1922. Having sought all her life to infuse spirituality into her art, she opened the School of Natya in New York in 1940, soon incorporated into La Meri's Ethnologic Dance Center, where she learned the movements and facial expressions of the *mudrā*.

26. Programme from the Olympia, 17 August 1906.

27. Cited by Jacques Pessis and Jacques Crépineau, *Le Moulin-Rouge* (Paris: Editions Hermé, 1989), p. 78.

28. Ibid.

29. Ill. 68-77, cited by Hélène Pinet in *Ornement de la durée* [*Lasting Ornament*] (Paris: Musée Rodin, 1987), p. 18.

30. Library of the Arsenal, Paris, Ro 11 993.

31. Isadora Duncan lodged near Rodin in the Hôtel Biron in 1908, and then in Meudon just before the war. See *Rodin et les danseuses cambodgiennes* [*Rodin and the Cambodian Dancers*] (Musée Rodin, 2006), p. 32.

32. Auguste Rodin, "Sur Isadora Duncan" ["On Isadora Duncan"], *Bulletin de L'Oeuvre*, n° 11, Paris, 1911.

33. *Rodin et les danseuses cambodgiennes* [*Rodin and the Cambodian Dancers*] (Musée Rodin, 2006), p. 31.

34. Georges Bourdon, "Rodin et les petites princesses jaunes" ["Rodin and the Little Yellow Princesses"], *Le Figaro*, August 1, 1906.

35. Library of the Arsenal, Paris, Ro 15 722.

36. Thesis of Henriette Régnier, *La danse moderne inspirée des gestes et attitudes des animaux* [*Modern Dance Inspired by Animal Movements and Attitudes*] (Paris: Editions Peyronnet, 1925).

37. In *Rodin et les danseuses cambodgiennes* [*Rodin and the Cambodian Dancers*] (Musée Rodin, 2006), p. 74, Hugues Herpin recounts that he had shown the *Dance Movements* sculptures to the Cambodian Royal Ballet. Two of the sculptures caught the dancers'

attention. With a slight modification of the arm positions, "Type E" reminded them of "a frequently used warmup exercise" and "Type F" looked like a movement characterising the role of a "giant".

38. Inv. D. 28829.

39. Inv. D. 4418.

40. Inv. D. 4417, 4421. He wrote to Rilke on 8 November 1907, "Perhaps I have not sent enough of the Cambodians, which are comparable to the Psyches if I may say so, because I have not been able (despite my impetuous desire) to fully engage with this profound and beautiful dance, and my translation is a bit 18th century."

41. In the first exhibition dedicated to 350 of Rodin's drawings, held in 1907 at the Bernheim-Jeune gallery and then at the one in Vienna in the same year, some 100 of them were entitled *Psyché* [*Psyche*] and around 20 were of the Cambodian dancers. (Letter from Rilke to Rodin, November 3, 1907.)

42. Inv. D. 5121.

43. Inv. D. 1629.

44. Inv. D. 1629.

45. D. 4998 DP.

46. These drawings are connected to *karaṇa* 44: Inv. D. 1043, 1629, 2881, 5121; the following drawings are connected to *karaṇa* 65: Inv. D. 6295, 6296, 4405, 4417, 4421, 4998, 5739, 5740, 5742, 1746, 2828, 2829, 2838, 2843.

47. *Gandharvas* and *apsaras*.

48. The plates numbered XXVII to XLVII in the *Ars Asiatica III* review correspond to Victor Goloubeff's text. Auguste Rodin held some of these photographs in his personal collection (See Musée Rodin archives).

49. *Rodin et les danseuses cambodgiennes* [*Rodin and the Cambodian Dancers*] (Musée Rodin, 2006), pp. 77–78. In an article, entitled "Le ballet royal Khmer" ["The Khmer Royal Ballet"], Proeung Chhieng explains that his art includes some one hundred postures (*khbach*) associating precise movements of the hands and feet. He describes 59 drawings by Auguste Rodin that correspond to one of the postures. *Khbach techent*, a pose balanced on one leg with the other raised in the back, with numerous variations, signifies flying away and travelling.

50. Inv. Imp. 90.

51. Inv. Cp. 8.

52. Photo excerpt from the film *La danse de Çiva* [*The Dance of Shiva*] directed by Lionel Tardif in 1985 in the great Shivaist temples of Tamil Nadu.

53. Inv. Co. 157. In his *ūrdhva tāṇḍava* form, the god dances, with his son Skanda, god of war, on his right, and his son with the elephant head, Ganesha, on his left. It is the fifth form of the god Shiva as a dancer. With one leg taut, held up against the ear, and the other lightly bent, the god has eight arms: in his right hands, he protects, holding a lance, a drum, and a lasso, and in his left hands, he holds a skull, fire, and a bell. The last arm crosses the body like an elephant's trunk. *tāṇḍava* represents the

masculine attributes, vigor. See *Pratima-kosha, Encyclopedia of Indian Iconography,* vol. I (Bangalore: Kalpatharu Research Academy Publication, 1988), p. 192.

54. Auguste Rodin, "Fresques de danse" ["Dance Frescoes"], *Montjoie,* number 1-2, January-February 1914.

55. D. 4517, on the front of five other studies.

56. The iconography of Indonesian temples bears witness to this intrinsic link with some of the 108 *karaṇa* created by the god of dance, Shiva. See J. Fontein, introduction to *The Sculpture of Indonesia* (Washington/New York: National Gallery of Art/Harry N. Abrams, 1990).

57. K 25, 35, and 40.

58. Co. 105, 108, and 159. It is possible that it deals with Shiva in his *gaṅgādhara mūrti* form, taking the river goddess Gaṅgā in his tangled hair when he descends to place her upon his raised thigh. Or perhaps when she is seated upon his knee, he wraps her in his arm as in the sculpture from the Kailasanātha Temple. In this pose, he still has one leg raised, usually the left, with bent knee, and his head leaning slightly to look at the goddess. The raised hand holds one of his locks of hair so that the water can fall upon the earth in a limited flood; his other hand is wrapped around the goddess's waist or holds a symbol such as the axe or antelope. The text that Victor Goloubeff published in *Ars Asiatica III* is dedicated to "the descent of the Gaṅgā to Earth at Mavalipuram," illustrated by several photographs (Pl. XXVII-XLVII). His study is the result of research he shared during the summer of 1914 with Mr Jouveau-Dubreuil at the Asiatic Society of Paris. It thus took place a few months after Rodin's acquisition of 15 wooden panels from Indian temples, including three sculptures of the goddess Gaṅgā. It is quite possible that Goloubeff recounted to Rodin certain myths concerning this goddess. The conclusion of Goloubeff's research in 1914 consists of connecting this rock statue from Mahabalipuram to an episode in the epoch of *Rāmāyana* (I, 38-44): "In order to avoid a cataclysm that could lead to the demise of men, a god such as Shiva should moderate the fall of floods by making them first fall upon his head."

59. In the July 28, 1906 issue of *Illustration,* Georges Bois, Inspector of Professional Instruction in Indochina and delegate of Fine Arts to the Colonial Exposition of Marseille, transcribed Rodin's remarks during their conversations at the hotel in Marseilles during the exposition.

60. This is the theme of one of the wood panels acquired by Rodin in 1914 (Co. 158).

61. Auguste Rodin, "Fresques de danse" ["Dance Frescoes"], *Montjoie,* number 1-2, January-February 1914.

62. Inv. D. 4430.

63. *Rodin et les danseuses cambodgiennes* [*Rodin and the Cambodian Dancers*] (Musée Rodin, 2006), pp. 78–79.

64. Charles Morice, introduction to *Les Cathédrales de France* [*The Cathedrals of France*], by Auguste Rodin (Paris: Librairie Armand Colin, 1914), p. 66.

65. Each bronze is harmonised by six points of view: the face, the profile, the back, then a

close-up of the head, a profile from above the bust and head, and finally a close-up of the two hands closest to the body (the two others hold a drum and fire).

66. The proof is in this comment written by Rodin on the back of photograph 16467—and also present in his text—corresponding to Plate VIII in *Ars Asiatica III* showing a straight profile of the second bronze: "From a certain angle, Shiva is a slender crescent."

67. Co. 651. Bénédicte Garnier, *Rodin, L'antique est ma jeunesse* [*Rodin, Antiquity is my youth*], (Musée Rodin, 2002), p. 30.

68. Paul Gsell, "Chez Rodin," in *L'art et les artistes* [*Art and Artists*], number 10, March 1910, p. 395.

69. Ricciotto Canudo, "Une visite à Rodin" ["A visit to Rodin"], *Revue hebdomadaire*, April 5, 1913, pp. 27–29.

70. Ananda Coomaraswamy, "Notice sur l'entité et les noms de Çiva" [Note on the Entity and the Names of Shiva], *Ars Asiatica III* (Brussels and Paris: National Bookstore of Art and History [Librairie National d'art et d'histoire], G. Van Oest and Company, 1921), p. 15.

71. See the analysis of this work by Rodin in *L'art, Entretiens réunis par Paul Gsell* [*Art, Interviews Assembled by Paul Gsell*], Les Cahiers Rouges collection (Paris: Editions Grasset, 1911), pp. 45–55.

72. Ph. 16479.

73. Ph. 16471.

74. *Ars Asiatica III* (Brussels and Paris: National Bookstore of Art and History [Librairie National d'art et d'histoire], G. Van Oest and Company, 1921), p. 17.

75. Ibid., p. 21.

76. Saligrama Krishna Ramachandra Rao, *Pratima-kosha, Encyclopedia of Indian Iconography,* vol. II, (Bangalore: Kalpatharu Research Academy Publication, 1988), p. 4.

77. Fragments (472) and (652).

78. The Venus of Medici, the most famous artwork of Antiquity and one of the most often copied models. Of uncertain origin, the piece was first substantiated in the Medici collections only in 1598. The marble statue held at the Uffizi Gallery in Florence is only a Greek or Roman copy based on a prototype by Praxiteles dating from the first century BC. A modern restoration of the arms by Ercole Ferrata explains the statue's quite slender, mannerist fingers, which elongate the arm in a curious manner.
In the interviews collected by Paul Gsell, [*L'art, Entretiens réunis par Paul Gsell* (Paris: Editions Grasset, 1911), p. 173)], Rodin considers the Venus de Milo as the "most beautiful Antique inspiration: it is measured delight, it is an even and rhythmic *joie de vivre,* moderated by reason." He had just recalled how the "gentle undulation of the whole work" results in a slight gap and balance between "flight of the shoulders towards the left one and to the front, flight of the hips toward the right one, equilibrium falling on the right foot while the left leg is more free."

79. Auguste Rodin, *L'art, Entretiens réunis par Paul Gsell* [*Art, Interviews Assembled by Paul Gsell*] (Paris: Editions Grasset, 1911), p. 46.

80. Auguste Rodin, "Sur Isadora Duncan" ["On Isadora Duncan"], *Bulletin de L'Oeuvre*, n° 11, Paris, 1911.

81. Guillaume Apollinaire, *Oeuvres complètes* [*Complete Works*], vol. II, La Pleïade, (Paris: Editions Gallimard, 1991), p. 164.

82. Rainer Maria Rilke, *Auguste Rodin,* trans. C. Caron, (Paris: La Part Commune, 2002), p. 202.

83. Letter of 1 November 1906, in Alain Beausire, Hélène Pinet, Florence Cadouot and Frédérique Vincent (dir.), *Correspondance de Rodin - 1860–1917* [*Rodin's Correspondance - 1860–1917*], vol. I–IV, (Paris: Musée Rodin, 1985–1992).

84. I. Jianou, *Rodin* (Paris: Editions Arted, 1970), p. 68.

85. Auguste Rodin, *L'art, Entretiens réunis par Paul Gsell* [*Art, Interviews Assembled by Paul Gsell*] (Paris: Editions Grasset, 1911), p. 111.

86. Gaston Calmette's article in the May 30, 1912, issue of *Le Figaro* critiqued Nijinsky thus: "Those who tell us about the art and poetry in this performance are mocking us. […] We experienced an unseemly Faun with vile movements of erotic bestiality and gestures of over-the-top indecency." In response, Diaghilev published in the following issue two texts laudatory of Auguste Rodin and Odilon Redon. That summer, Nijinsky posed for Rodin, who made several drawings and sculptures of him.

87. *Le Matin,* July 1, 1912.

88. Letter of 11 May 1913, in Alain Beausire, Hélène Pinet, Florence Cadouot and Frédérique Vincent (dir.), *Correspondance de Rodin - 1860–1917* [*Rodin's Correspondance - 1860–1917*], vol. IV, (Paris: Musée Rodin, 1985–1992).

89. Letter of 8 November 1903, vol. II, ibid.

90. Letter of 10 October 1905, vol. II, ibid.

91. Ibid.

92. Pope Benedict XV could not tolerate another session of the planned poses, which he hurried to replace with some official drawings so that Rodin could create a bust of him. Letter from R. Sanz de Samper, Master of the Chambers to His Holiness, to Rodin, April 25, 1915, Musée Rodin archives. Auguste Rodin refused any commission for the bust of a living person that required him to sculpt based on photographs. He did not use Francis Willène's technique of photo-sculpture, created in 1861, for efficiently developing a sculpture based on 24 profile snapshots. Although Rodin's favorite technique involved profiles, beginning in 1896, this consisted of the artist walking about the figure, never stopping for a particular profile view, in such a way as to unify all of the profile views in a fluid movement. *Rodin sculpteur et les photographes de son temps* [*Rodin: The Sculptor in the Light of his Photographers*] (Paris: Editions P. Sers, 1985), p. 14.

93. The first citation comes from the *Tiruvācagam* by Māṇikka Vācagar, and the second is from the M*ahābhārata.* These references are given on page 16 of *Ars Asiatica III*, specifying that they have been translated in English by G.V. Pope, published by Oxford University Press, 1900.

94. Auguste Rodin, *L'art Entretiens réunis par Paul Gsell* [*Art, Interviews Assembled by Paul Gsell*] (Paris: Editions Grasset, 1911), p. 150.

95. Ibid., p. 121.

96. Ibid.

97. Stella Kramrish, *The Presence of Siva*, (Benares: Motilal BanArsidass, 1988), p. 440.

98. Loïe Fuller, *Quinze ans de ma vie* [*Fifteen years of my life*] (Paris: F. Juven, 1908), p. 247. Not only did this dancer pose for Rodin, but she also organised for him the first exhibition of some of his bronzes at the National Arts Club in New York in May 1903, adding several commentators to discuss his work.

99. This citation is from Françoise Le Coz, "Le mouvement: Loïe Fuller," in *Photographies*, no. 7, May 1985, cited by Hélène Pinet in *Ornement de la durée* [*Lasting Ornament*] (Paris: Musée Rodin, 1987). This includes numerous photographs of Loïe Fuller taken by Eugène Druet.

100. The proof is in this comment written by Rodin on the back of photograph 16467—and also present in his text—corresponding to Plate VIII in *Ars Asiatica III* showing a straight profile of the second bronze: "From a certain angle, Shiva is a slender crescent."

101. Auguste Rodin, *Les Cathédrales de France* [*The Cathedrals of France*] (Paris: Librairie Armand Colin, 1914), p. 33.

102. Rodin emphasises this element in the fourteenth chapter of *Les Cathédrales de France* [(Paris: Librairie Armand Colin, 1914), p. 48)], in which he describes one of the feminine figures as follows: "lit on the side", posing before him "with garlands of shadows stretching from the shoulder to the hip, and from the hip to the prominent rounds of the thigh." When he describes the same phenomenon in regard to the Hindu god in bronze, he uses nearly the same terms: "There are garlands of shadows stretching from the shoulder to the hip, from the hipbone to the thigh at right angles." These phrases represent an example of the similarities among the varied styles and epochs present in his art and in the very substance of his writing.

103. Ibid.

104. Rodin bought *Le Père Tanguy* [*Portrait of Père Tanguy*] from Van Gogh, a painter he admired for his negligence "of all the academic formulas" and his manner of placing himself "naively before nature" seeking "to translate it". In Paul Gsell, *L'art Entretiens réunis par Paul Gsell* [*Art, Interviews Assembled by Paul Gsell*] (Paris: Editions Grasset, 1911), p. 98.

105. Vincent Van Gogh (1853-1890): *Les Tournesols* [*Sunflowers*] (1888), *Champ de blé aux corbeaux* [*Wheatfield with Crows*] (1890).

106. Immanuel Kant, *Critique of the Power of Judgement*, ed. Paul Guyer, trans. Paul Guyer and Eric Mathews, (Cambridge and New York: Cambridge University Press, 2000).

107. Auguste Rodin, *L'art, Entretiens réunis par Paul Gsell* [*Art, Interviews Assembled by Paul Gsell*] (Paris: Editions Grasset, 1911), pp. 96–97

108. Isabelle Clinquart, *Musique de l'Inde du sud* [*Music of South India*] (Paris: Cité de la musique/actes Sud, 2001), pp. 63–67.

109. Katia Légeret, *Esthétique de la danse sacrée* [*Aesthetics of Sacred Dance*] (Paris: P. Geuthner, 2001), pp. 60–70.

110. No. 16467

111. The Sanskrit word for the lotus here is *pankaja* (*Nelumbium speciosum*) which means coming from (*ja*) the mud (*panka*). The Sanskrit term *padma* is more contemporary and one of its meanings is a very high number, in the billions of billions. In the subsequent lines of cited text, the sages indeed see not two but thousands of lotus feet of the god Shiva.

112. L'Ishvaragîtâ, vol. v, (Paris: Geuthner, 1933).

113. L'Ishvaragîtâ, vol. III and VIII, (Paris: Geuthner, 1933).

114. Bhagavad Gita 5, 10.

115. Letter from Rodin to Monet, 22 September 1897, in Alain Beausire, Hélène Pinet, Florence Cadouot and Frédérique Vincent (dir.), *Correspondance de Rodin - 1860–1917* [*Rodin's Correspondance - 1860–1917*], vol. I, (Paris: Musée Rodin, 1985–1992).

116. Letter from Rodin to Monet, July 1891 and then in November 1894, stating that they had met the painter Cézanne, Ibid.

117. Auguste Rodin, *Les Cathédrales de France* [*The Cathedrals of France*] (Paris: Librairie Armand Colin, 1914), p. 105.

118. Inv. 4902.

119. Inv. 3925.

120. Inv. 5751.

121. Rainer Maria Rilke, "L'Homme qui marche (Conference de 1907)" ["The Walking Man (Conference of 1907)"], trans. Victoria Charles, in *August Rodin* (New York: Parkstone International, 2011).

122. F.V. Grunfeld, *Rodin,* (Paris: Fayard, 1988), p. 559.

123. Auguste Rodin, *Les Cathédrales de France* [*The Cathedrals of France*] (Paris: Librairie Armand Colin, 1914), p. 129.

124. Ibid., p. 130.

125. Ibid., p. 46.

126. Letter from Rainer Maria Rilke to Clara Rilke-Westhoff, Paris, 15 October 1817, in R.M. Rilke *Oeuvres III, Correspondance* [*Works III, Correspondence*] (Paris: Editions du Seuil, 1976), p. 110.

127. Auguste Rodin, *Les Cathédrales de France* [*The Cathedrals of France*] (Paris: Librairie Armand Colin, 1914), p. 148.

128. Ibid., p. 125.

129. Ibid., p. 69.

130. Ibid., p. 21.

131. Ibid., p. 11.

132. E. B. Havell, "La Trimurti d'Elephanta" ["The Trimurti of Elephanta"], *Ars Asiatica III* (Brussels and Paris: National Bookstore of Art and History [Librairie National d'art et d'histoire], G. Van Oest and Company, 1921), p. 21.

133. This artwork was part of the 2008 exhibition at the Musée Rodin "La passion à l' œuvre, Rodin et Freud collectionneurs" ["Passion for works of art, Rodin and Freud as collectors"].

134. Judith Cladel, *Auguste Rodin pris sur la vie* [*Auguste Rodin live in life*] (Paris: La Plume, 1903), pp. 91–92.

135. Georges Didi-Huberman, *Ouvrir Vénus* [*Opening Venus*] (Paris: Gallimard, 1999).

136. Ibid., p. 18. Words underlined by author.

137. Ibid., p. 22. The three terms refer to the aesthetic of Aby Warburg (in his 1906 *Essais florentins* [*Florentine Essays*]), one of the founders of the discipline of iconology.

138. Inv. Co. 104.

139. Auguste Rodin, *Les Cathédrales de France* [*The Cathedrals of France*] (Paris: Librairie Armand Colin, 1914), p. 139.

140. Inv. D. 598, 760, 2711, and 7176.

141. D. 5700 and 5699.

142. D. 5073.

143. Rodin et les danseuses cambodgiennes [*Rodin and the Cambodian Dancers*] (Musée Rodin, 2006), p. 66.

144. Auguste Rodin, *Les Cathédrales de France* [*The Cathedrals of France*] (Paris: Librairie Armand Colin, 1914), p. 59.

145. Rodin, "Fresques de danse" ["Dance Frescoes"], *Montjoie,* number 1-2, January-February 1914.

146. Auguste Rodin discussed his research "on the naked human body" with Count Harry Kessler in January 1908.

147. D. 5699.

148. D. 4436.

149. Within his collection of drawings entitled "*Psyché*" ["*Psyche*"], certain drawings are of an unclothed dancer performing the *karaṇa* 50, while others have the same title but are of a clothed Cambodian dancer—D. 4496: "Dance of Psyche in the heavens". The pale yellow colour of the costume is the same as that of the background, one leg is raised behind the dancer, in the *karaṇa* of flight. Recall that in a 1908 exhibition at Leipzig, the Psyche drawings of both nudes and Cambodians were juxtaposed. Among the 103 drawings, number 83, *Cambodgienne* [*Cambodian*], shows a dancer in the same pose and same costume as number 84, entitled *Psyché* [*Psyche*].

150. Auguste Rodin, *Les Cathédrales de France* [*The Cathedrals of France*] (Paris: Librairie Armand Colin, 1914), p. 28.

151. Ibid., p. 62.

152. Ibid., p. 29.

153. Their correspondence ended in May 1914.

154. Letter to Gustave Geffroy, 10 April 1913, in Alain Beausire, Hélène Pinet, Florence Cadouot and Frédérique Vincent (dir.), *Correspondance de Rodin - 1860–1917* [*Rodin's Correspondance - 1860–1917*], vol. IV, (Paris: Musée Rodin, 1985–1992).

155. Amidst war and rationing, after 50 years of companionship, Rodin married the woman he had always called "Mr. Rodin" on 29 January 1917, just one month before her death. Rodin himself passed away on 17 November of that same year, victim of pulmonary congestion. Already quite ill, in 1916, he donated his life's work to the French government. The National Assembly then voted to establish the Musée Rodin in the Hôtel Biron building, and it opened to the public on 4 August 1919.

156. Letter to Mario Meunier, 2 March 1913, in Alain Beausire, Hélène Pinet, Florence Cadouot and Frédérique Vincent (dir.), *Correspondance de Rodin - 1860–1917* [*Rodin's Correspondance - 1860–1917*], vol. IV, (Paris: Musée Rodin, 1985–1992).

157. Several lines later (p. 138), he contemplates the mouth, lips, and eyes of this woman lying down, with the same words as those utilised to describe the face of the god Shiva:

> *These lips are like a lake of pleasure that shares the quivering nostrils, so noble!/ The mouth undulates in delicious moisture, sinuous as a snake. The eyes enlarge, closed at the confection of lashes./ The words that move as they escape the lips are drawn by these lips, by their delicious undulation./ The eyes, which have but one place to hide, are nestled in the purity of line and in the tranquility of stars.*

In the text on Shiva, we find these same four phrases, but they are dissociated from each other and each is but a fragment:

> *These lips are like a lake of pleasure, bordering the nostrils which quiver in their nobility.*
> *The mouth undulates in delicious moisture, sinuous like a snake; the closed eyes are enlarged, closed amidst a confection of lashes.*
> *The lips that create words, moving as they escape: such a delicious serpent in motion!*
> *The eyes that have but one place to hide are made of the purity of line, of the tranquility of nestled stars. The fair tranquility of these eyes; a tranquil drawing; the tranquil joy of this calm.*

158. Gustave Coquiot, *Rodin à l'hôtel de Biron et à Meudon* [*Rodin at the Hôtel Biron and at Meudon*] (Paris: Editions Ollendorff, 1917), p. 58.

159. Donation number 36.

160. Auguste Rodin, *Les Cathédrales de France* [*The Cathedrals of France*] (Paris: Librairie Armand Colin, 1914), p. 105.

161. Auguste Rodin, *L'art, Entretiens réunis par Paul Gsell* [*Art, Interviews Assembled by Paul Gsell*] (Paris: Editions Grasset, 1911), p. 48.

162. Letter of 21 October 1908, Rainer Maria Rilke, *Correspondance*, trans. Blaise Briod and Piere Klossowski (Paris: Editions du Seuil, 1966).

163. Auguste Rodin, *L'art, Entretiens réunis par Paul Gsell* [*Art, Interviews Assembled by Paul Gsell*] (Paris: Editions Grasset, 1911), p. 179.

164. On their opposite sides is a sculpture of the river goddess Gaṅgā. This ensemble of

panels was purchased by Rodin on 3 January 1914 from Léon Marseille, at 16 rue de Seine in Paris. On the receipt provided by the merchant, it stipulates "fifteen sculptures in wood and stone from Hindu temples, for the sum of ten thousand francs." (Musée Rodin archives).

165. Inv. D. 5188.

166. Emile Guimet, G. Le Bon, *Mirages indiens* [*Indian Mirages*], (Paris: Editions Phébus, 1992), pp. 72–73, 74: The general allure of the temple dancers that Emile Guimet met in India at Madurai and that he describes in his book *Mirages indiens* [*Indian Mirages*], is quite different from the allure adopted by Mata Hari: when Guimet watched them perform their "pantomime" in the temple, they remained dignified and clothed, controlling all of their movements, even though this was "a love drama". They did not manage to sit all together upon one chair—it was the first time in their lives—so that his friend Regamey could draw them: it seemed to have "made them undergo a terrible operation" and as soon as he touched them to pose them "the unhappy girl let out a cry as if someone was going to burn her."

167. Auguste Rodin, *Les Cathédrales de France* [*The Cathedrals of France*] (Paris: Librairie Armand Colin, 1914), p. 139.

168. For more on this subject, see Nicole Barbier, "Assemblages de Rodin" ["Rodin's assemblages"], in *Le Corps en morceaux* [*The body in pieces*] (Paris: Musée d'Orsay, 1990), pp. 225–241.

169. Inv. D. 4845.

170. Inv. D. 4523.

171. As demonstrated by Rodin's drawing entitled *Espace* [*Space*]: Inv. D. 4841.

172. Books IV to VI.

173. One day, when Rodin asked Anatole France for the academic definition of Psyche and he was met with the response, "It's a little woman who voluntarily shows her..." Rodin exclaimed, "My word, that's exactly how I saw it. And you make me happy", in Frederic V. Grunfeld, *Rodin* (1988), p. 559.

174. Fernand Divoire, *Découvertes sur la danse* [*Dance Discoveries*] (Paris: G. Grès et Cie, 1924).

175. *La Danse revue*, 12, Paris, 1921.

176. Inv. D. 4421, unpublished.

177. Auguste Rodin, *Eclairs de pensée, écrits et entretiens* [*Flashes of Thought, Writings and Interviews*] (Paris: Editions Olbia, 1998), p. 71.

178. This play was translated to French by Lyne Bansat-Boudon in her book *The Theatre of Kâlidâsa,* (Paris: Editions Gallimard, 1996).

179. This place is called La Folie Neubourg or Clos Paven, at 68 Boulevard d'Italie in Paris. Camille Claudel had just left her parents' home to stay alone in a room on this same boulevard.

180. This refers to act VII, v. 24.

181. It includes 14 essays on India. One of them has the same title, *The Dance of Çiva*, and dates from 1918. It also includes a photograph of one of the two bronzes studied

by Auguste Rodin, with the following caption: "Cosmic dance of Naṭarāja, Brahman bronze, Southern India, 12th century, Madras Museum." This is one of the two bronzes photographed in *Ars Asiatica III*, the one without the circle of flames surrounding the dancing god.

182. One year later, Ananda Coomaraswamy published a book in English entitled *The Dance of Shiva*. Victor Goloubeff explained in the bibliographic notes of *Ars Asiatica III* that this English translation (with which M. Gopala Krishnayya Duggirala was associated) "furnished the photo editor with precious information on sacred dance."

183. Georges Didi-Huberman and Laurent Mannoni, *Mouvements de l'air* [*Movements of the Air*] (Paris: Editions Gallimard/Réunion des musées nationaux, 2004).

184. Anonymous, *La Danse serpentine de Loïe Fuller* [*The Serpentine Dance of Loïe Fuller*], around 1894, kinetograph of 90 photographs coloured by stencil, Paris, private collection, in Georges Didi-Huberman and Laurent Mannoni, *Mouvements de l'air* [*Movements of the Air*] (Paris: Editions Gallimard/Réunion des musées nationaux, 2004), p. 295, and Georges Didi-Huberman, *L'empreinte* [*The Imprint*] (Paris: Centre Georges Pompidou, 1997), and *La ressemblance par contact: archéologie, anachronisme et modernité de l'empreinte* [*Similarity by Contact: Archeology, Anachronism and Modernity of the Imprint*] (Paris: Editions de Minuit, 2008), particularly the chapter "L'empreinte comme image dialectique chez Rodin" ["Imprint as dialectical image in Rodin's work"].

185. However, in India at that time period, with the 108 poses of the God represented in sculpture in the great temples of southern India, one was led to believe in an inseparability of dance and sculpture and in an artistic practice reduced to a succession of poses. This conception was reinforced in 1936 by the first publication in English of the fourth chapter of the *Nāṭyaśāstra* dedicated to these 108 poses and illustrated by the 93 wooden reproductions in the "Report epigraphical de 1914 (Madras) concernant les poses sculptées dans le temple de Chidambaram dédié au dieu Çiva" ["1914 Epigraphical report on the sculpted poses in the Chidambaram temple dedicated to the god Çiva"] in B.V.N. Naidu, P.S. Naidu, O.V.R. Pantlu, *Tandava Lakshanam*, (Madras: G.S. Press, 1936). Padma Subrahmanyan was the first *bharatanāṭyam* artist in the 1960s to critique this reduction of movement to poses and to demonstrate in her university dissertation that these sculptures represented but moments of the *karaṇa*, which were irreducible to photographic instants of a choreography; *Karanas in Dance and Sculpture,* (Madras: Annamalai University, 1963).

186. Gustave Geffroy, "Auguste Rodin", in *La vie artistique* [*The Artistic Life*] (Paris: Editions Dantu, 1899), p.25.

Translated from the French by Jennifer Post Tyler

LIVING STILLNESS: A COLLECTION OF ANCIENT GESTURES

BÉNÉDICTE GARNIER

Within the framework of this book, it seems interesting to make a slight digression to consider another Asian sculpture, the Buddha from Borobudur, or more precisely, its cast—a work that might at first seem far removed from the Shiva bronze, especially in terms of aesthetics. Rodin's text, "The Dance of Shiva", was an interpretation and a literary commentary; for this cast, he carried out a similar, but different exercise. First of all, the Buddha was a work that he chose, rather than one that was suggested to him, and he commented on it by placing and presenting it in the garden of the Villa des Brillants, in Meudon. The literary interpretation was secondary. With both the Buddha and the statue of Shiva, however, the sculptor appropriated and recreated a work from the past.

FACING PAGE (FIG. 3): A group of Europeans posing in front of the Borobudur temple

The year 1900 marked a turning point in Rodin's life. He presented his entire oeuvre for the first time in Paris, at the Universal Exhibition, in a purpose-built pavilion on the Place de l'Alma. This event was to bring him international renown, and considerable wealth as a result of subsequent public and private commissions. Curious to discover the foreign pavilions, he explored the aisles of the exhibition, confiding to the newspaper *La Presse* on 13 October 1900:

> Dear Monsieur Bailby,
>
> You asked me my impression of the Exhibition and what its highlight might be. To answer you from an artistic point of view, I believe the Far Eastern section made the strongest impression on me. The Cambodian staircase and bas-reliefs from the Sino-Dutch monastery seemed to me of a wonderful art such as we have never seen before, and the exotic dances – especially those performed by Loie Fuller and Sada Yacco – of a most spirited artistry and prodigious perfection.
>
> Yours most sincerely,
> Rodin.[1]

More than ten years before his text on Shiva, Rodin already associated Asian sculpture and dance in his memory with all the images he had seen at the Universal Exhibition. At that time, he was especially familiar with Greek and Roman art—that of his years of study—but was interested in the art of Assyria and Egypt too. He discovered Japanese prints in the 1880s at gatherings at the home of the Goncourt brothers or of his friend Claude Monet, but was still largely unfamiliar with Indian and South East Asian art, displayed for its exoticism at universal or colonial exhibitions.

The two monuments mentioned by Rodin, presented as companion pieces, were the Cambodian staircase and pagoda (a reconstruction of the hill and royal pagoda of Phnom Penh) and the Javanese temple of Candi Sari. They were shown in the Dutch East Indies pavilion at the Trocadéro,

and described at length in the exhibition guides. The reconstruction was decorated with relief friezes and Buddhas from the Borobudur temple, but also with elements from the temple of Prambanan. Visitors to the exhibition, therefore, saw a makeshift composite monument that bore no resemblance to the originals. (Fig. 1). At the entrance to the site was a row of statues of Buddha, isolated on modern pedestals like statues by contemporary artists. (Fig. 2) These casts had been made on site in Borobudur by E. von Saher, director of the school of industrial art, and architect of the exhibition's colonial section.[2] The Javanese dancers, who had already performed in 1889—described in the visitors' guide as "strange, supple and lively little dolls", gave performances in the South Pavilion.[3]

The Indonesian temple of Borobudur on the island of Java dated from the 8th and 9th centuries and had been excavated in 1814 by the British governor general of Java, Thomas Stamford Raffles. Few Europeans had seen it in 1900 and Rodin, unlike his friend Albert Kahn, was not a great traveller. At that time, he contented himself with his travels in Europe, but owned a photograph of the temple, probably given to him by the anonymous group posing in front of the building. (Fig. 3)

(FIG. 2): Dutch East Indies pavilion entrance, World Fair, 1900

ABOVE LEFT (FIG. 1): Candi Sari, World Fair, 1900

The Universal Exhibition opened on 15 April and closed its doors on 12 November 1900. The sculptures remained there for a few days before undergoing their various fates. Most of the casts from the temple were presented to the Indochinese museum at the Trocadéro by Bouwens van der Boijen, the architect who had "arranged this very curious specimen of Far Eastern art." After 1920, they were described as "a little tired, worn by rain, transportation and the ever-perilous passage through a busy exhibition."[4] The task of moving them was entrusted to Louis Delaporte, chief curator of the Trocadéro Museum, after agreement between the director of the Beaux-Arts and the minister of the Dutch colonies. The operation was carried out between 15 November 1900 and 14 January 1901; the dismounting of the casts and demolition of the palace were ordered in December and completed in mid-January.[5]

However, a group of five Buddhas reappeared at Rodin's Meudon home, the Villa des Brillants, and it is interesting to trace their history.

Rodin took a keen interest in casts in general, and in the museums that exhibited them—including the Museum of French Monuments, which he explored with Antoine Bourdelle. It was not unusual for him to be presented with the plaster cast of a work he had admired, and he often expressed his support for the preservation of past monuments. So was he presented with these works because of the view he had expressed in the press, and because of another remark he made (together with the sculptors Jules Desbois and Antoine Bourdelle) concerning the urgent need to safeguard the casts from the Cambodian temple, companion piece to that of Borobudur? "It's a revelation," they said,

> a completely new conception of art, of which only connoisseurs – specialists of Indochinese rituals, customs and habits – had any idea. But as it has now been 'revealed' to the public, let us keep it here to popularize it: our artistic culture will be all the richer. Let us not deprive ourselves of this prestigious form. The existence of the Exhibition would be justified by only two or three works of such value. So let us conserve the Khmer temple and its marvelous crypt, and if consolidation work is necessary, let it be done.[6]

Almost 40 years later, Antoine Bourdelle still remembered Rodin's enthusiasm for the sculpture of Borobudur:

> And I heard so many voices in Rodin! One saying how great Hindu art is. Among other examples, the temple of Java, casts from which (a series of splendid high-reliefs) have remained at the Trocadéro, and which represents one of sculpture's highest achievements. Indochinese pagodas, or Khmer art, ineffable and awesome in their artistry.[7]

In his desire to please Rodin, Bourdelle endeavored to save the famous casts, appealing to the Javanese consul:

> Mr. Rodin and I are very keen not to allow the destruction of the bas-reliefs on the outer balustrade and the Gods seated on pedestals outside the Temple of Java at the Universal Exhibition. We have the honor, Sir, to ask on what conditions we might remove those plasters before they crumble to nothing, destroyed by rain or demolition workers.[8]

Although it is most likely that the Buddhas were transferred to Meudon after the Universal Exhibition, their presence there was first recorded rather a long time later. Georg Treu, who stayed at Meudon in the fall of 1903, mentioned them in an article published first in 1904.[9]

(Fig. 4): The peristyle of the Pavillon de l'Alma.

Rodin began to construct new buildings on the site around the Villa des Brillants in 1900 and 1901. When the Universal Exhibition closed, he built a museum of antiquities resembling a Greek temple, to house the large collection that he could then afford. Soon after, in 1901, he had the precious Pavillon de l'Alma reconstructed in his garden to serve as a studio-museum. Four Buddhas could be seen beneath its peristyle, calmly aligned as if waiting, slightly out of place among the statues by Rodin and his collection of antiquities. (Fig. 4) Paradoxically,

Rodin does not seem to have been interested in the idea of a series; he chose to isolate a fifth Buddha, the Buddha Amitabha (or "infinite light"), whose hands are joined in the *dhyana mudra* gesture of meditation, on a plot of land acquired by Rose Beuret, his lifelong companion, in 1902.

So the sculptor kept five Buddhas at Meudon, belonging to the group of the five Jinas (or Buddhas in meditation)—almost identical figures, differentiated by the position of the arms and hands. And these Buddhas correspond to the group of statues at the Universal Exhibition, isolated on pedestals at the entrance to the temple.

Rodin placed the Buddha Amitabha to the west, as on the temple of Borobudur; it stood out, on a mound that seemed designed for that purpose, overlooking the end of the garden. To reach it, Rodin walked along a well-

defined path, seeing it from above (a view he particularly liked) before admiring it close up. The Buddha was visible from the windows of the Villa or the Pavillon de l'Alma, emerging distinctly as if to mark the territory, indicating the landscape and the course of the River Seine in the distance. (Fig. 5) The statue could be admired from all around, and was much photographed. (Fig. 6) In splendid isolation, it faced the Greek and Roman sculptures placed on columns or fixed to the walls in front of the little antiquities museum, and became a major stopping point on a stroll through the garden. (Fig. 7)

This addition of an Asian touch recalls previous examples, such as the Buddha in Henry Cernuschi's house, the gardens of Claude Monet and Albert Kahn, the Goncourt brothers' home—examples that Rodin already knew. The five Buddhas he acquired changed significance as they moved from Borobudur to the Universal Exhibition, then to the sculptor's home. In his pantheon of Greek and Roman sculpture, Rodin introduced an element that was both foreign and familiar, a bright presence in the daylight and the open air. As he did with his literary text on the Shiva Nāṭaraja, he compared the various arts of the past with his own work, according to a system of visual correspondence.

The Buddha became one of the attractions of the garden, inspiring

FACING PAGE ABVOE (FIG. 5): The Buddha and the Seine view

FACING PAGE BELOW (FIG. 6): Rodin in front of the Buddha

(FIG. 7): Rodin with a group of friends in front of the Buddha installation in Meudon

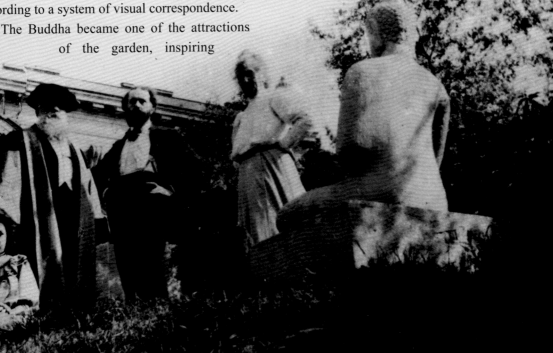

photographers to capture it in images and visitors to describe it in writing. In 1904, Ludwig Weber compared the hermitage at Meudon to Nietzsche's house:

> Rodin, without knowing Nietzsche, was enraptured by the same thoughts that enraptured Nietzsche the great loner. A pantheon is currently being erected in Weimar in memory of Nietzsche's work. Rodin is a loner in the same way as Nietzsche. The artist has set up residence in Meudon, near Paris. That is where he lives in isolation, alone, like Klinger, with the figures of his imagination. The statue of Buddha in his garden is the symbol of the peace ardently desired by a sublime and glorious humanity. This is his world, and there he is all himself."[10]

In March 1905, Georg Treu, curator of the Albertinum in Dresden, remembered having seen it:

> On a little hillock in his garden in Meudon, with a view of the distant countryside, is a copy of an Indian Buddha – symbol and guardian of the reverence and renunciation of the world that Rodin has always desired, to which he constantly aspires and has never attained.[11]

The Buddha also fascinated the authoress Nourye Neyr-els-Nissa in 1907:

> The mystical Buddha with its enigmatic smile, who greets us amid the greenery, shares its soothing thoughts with the world of marble all around it. During the hour I spent among those figures, it brought me gentle appeasement too, contemplation above the world and everyday things. The blissful serenity of that stone god communicates itself to everything; the long, cool greenery of the trees, the insects of the garden, the flowers are all imbued with it.[12]

Rainer Maria Rilke could admire the statue from the little house on Rodin's property where he stayed from September 1905 to May 1906 (fig. 8): "Below my window, the gravel path climbs toward a small hill crowned by

a statue of Buddha, with its steadfast muteness, which imparts with silent reserve, beneath every night and daytime sky, the inexpressible plenitude of its pose. It is the center of the world, I told Rodin…"[13] In November 1905, he wrote to Rodin, who was traveling at the time, "…Only the Buddha remains in divine equilibrium (brightly illuminated by the snow that lies on its breast – rather like *Thought* in the Luxembourg). Ruler, even, and scholar of this strange world."[14] Inspired by the theme, and perhaps by

(FIG. 8): Rainer Maria Rilke at Meudon

this specific work, Rilke published three poems in 1907 and 1908 in his collection entitled *New Poems*:[15]

Buddha

As if he listened, Silence, far and far….
we draw back till we hear its depths no more.
And he is star. And other giant stars
which we cannot see stand about him here.

Oh, he is all. And really, do we wait
till he shall see us? Has he need of that?
Even should we throw ourselves before him,
he would be deep, and indolent as a cat.

He has been in labor for a million years
with this which pulls us to his very feet,
He who forgets that which we must endure,
who knows what is withdrawn beyond our fate.

Buddha in Glory

Center of all centers, core of cores,
almond, that closes tightly in and sweetens, –
all this world out to the farthest stars
is the flesh around your seed: we greet you.

Look: you can feel how nothing any longer
Clings to you; your husk is in infinity,
And the potent juice now stands there pressing.
And from outside a radiance assists it,

For high above, your suns in their full splendor
Have wheeled blazingly around,
Yet inside you now, secure and growing:
What lasts beyond the suns.

Far from Borobudur, the statue blended into the symbolic image of the place drawn by Rodin and his contemporaries: a place of introspection, solitude, silence, reverence and meditation, the center of the world and the great Whole. The Buddha became a metaphor—not for the sculptor, but for his desire. (Fig. 9)

The Buddha of Borobudur embodied Rodin's aspiration to religious sentiment, a form of prayer that expressed itself in contact with art in all its forms, rather like the feelings he experienced beneath a cathedral vault or in the presence of Greek art. With age, he sought the kind of calm he perceived in all forms of ancient art. "Greek art is physical joy and spiritual

(FIG. 9): The Buddha in front of Rodin's house

serenity," he said.[16] The sculptor also associated Greek art with the feelings of stillness, silence and withdrawal that he inevitably experienced in front of funerary stelae, and which reminded him of his own declining life in the solitude of Meudon. He related the ancient to darkness and burial, to the farthest reaches of both time and space, and in the term "ancient", associated all the arts of Asia.

As in his text on the Shiva Nataraja, he noted his impressions and musings on the Buddha as literary fragments, captured and given rhythm like a breath:

> A Javanese plaster piece that I now see as the most beautiful sculpture.
> Ah, serene thought, like time, in unison.
> Nirvana pleasure without movement.
>
> The Nirvana Buddha imperceptibly breathes, or rather, silently takes its pleasure. The Far East creates an effect with few means, which are scarcely apparent as they misled a great artist, who long considered it exotic and uncivilized.[17]

This literary inspiration and passion for the statue of Buddha are recurrent throughout Rodin's work. Shortly before 1900, inspired by all ancient forms, he adopted fragmentation and simplification in both his drawing and sculpture. Referring to the *Monument to Balzac*, rejected by the Salon of 1898, he asserted that his aim had been "to head in the direction of the Egyptians [...] Greeks [...] Orante? Hera of Samos."[18] Not far from the statue of Buddha, a cast of the Apollo of Thera had pride of place among the plasters in the Pavillion de l'Alma. Was *Balzac* another Buddha, rising like a stone in the garden at Meudon? And *Thought*, the work mentioned by Rilke, or the *Torso of a Young Woman with Arched Back* (about 1910)? (Fig. 10) In 1906, Valentine de Saint-Point had clearly addressed the issue of expression through movement or stillness in her article "The Dual Personality of Auguste Rodin"[19], in which she also emphasised the magical affinity between the artist's sculptures and the Meudon landscape. "The analogy between the human figure and the surrounding countryside is

FACING PAGE (FIG. 10):
Torso of a young woman with arched back, 1910

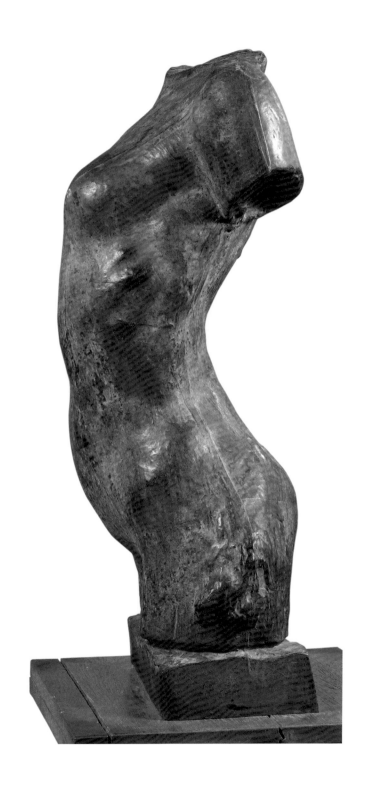

strangely and intensely striking. It grasps the mind like a truth so simple, and therefore universal, that it is unforgettable." (Refer Fig. 5)

The air and landscape interacted with the Buddha of Borobudur—a simplified body-structure, drawn in a single stroke, its limbs connected, with neither beginning nor end. This is perceptible, too, in drawings by Rodin, such as the *Vase Woman.* (Fig. 12)

After his research in the 1880s on the expressiveness and movement of the figures of the *Gates of Hell,* Rodin probably strove for the living

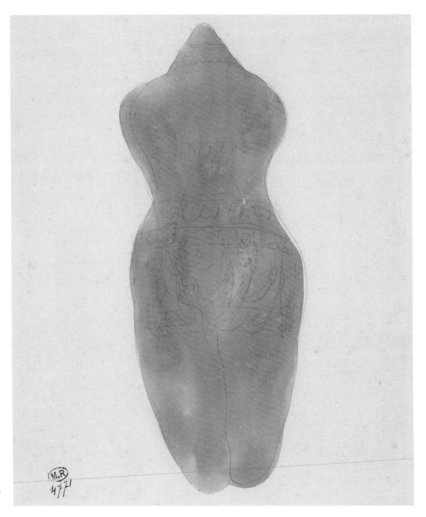

(FIG. 11): Woman as a vase, 1900, Auguste Rodin

stillness incarnated by the Buddha of Borobudur, among others—an image of the fusion of Rodin's art with that of India. The facade of the Château d'Issy was added to the garden at Meudon shortly after the arrival of the Buddha, in 1906–1909—another temple standing out against the sky, in front of which the sculptor's tomb was erected in 1917, topped by the statue of *The Thinker*—another modern Buddha, reinforcing the sacred nature of the place.

Endnotes:

1. "Une enquête de la Presse, Le clou de l'Exposition," *La Presse*, October 13, 1900.
2. Alfred Picard, *Exposition universelle de 1900 à Paris. Rapport général administratif et technique*, T. V, (Paris, 1902-1903), p. 73.
3. *1900 Paris Exposition, guide pratique du visiteur de l'exposition* (Paris: Hachette et Cie, 1900), p. 346.
4. Pierre Bracquemond, "Le Temple de Borobudur," *L'Amour de l'Art* (1920), pp. 136-140.
5. My thanks to Pierre Baptiste, Curator of the Musée Guimet, for informing me of his research on Louis Delaporte and the transfer of the casts to the Musée du Trocadéro (Archives of the Indochinese museum at the Trocadéro).
6. E. C., "Le temple khmer," *Les débats*, December 13, 1900.
7. Émile-Antoine, Bourdelle *La sculpture et Rodin* (Paris: Émile-Paul Frères, 1937), p. 26.
8. Letter from Antoine Bourdelle to the Consul of Java, n.d., Musée Rodin.
9. Georg Treu, "Bei Rodin," *General Anzeiger*, October 7, 1904.
10. Ludwig Weber, "Feuilleton. Leipziger Kunstverein. August Rodin," *Leipziger Tageblatt*, December 1, 1904.
11. Georg Treu, "Bei Rodin," *Kunst und Künstler*, March 1905.
12. Nourye Neyr-el-Nissa, "Chez Rodin," *Le Figaro*, May 4, 1907.
13. Letter from R.M. Rilke to his wife Clara, 20 September 1905, in Rainer Maria Rilke, *Oeuvres. III: Correspondance* (Paris: Le Seuil, 1976), p. 8.
14. Letter from R. M Rilke to A. Rodin, [November 1905], Musée Rodin archives.
15. Rainer Maria Rilke, *Oeuvres. II: Poésie* (Paris: Le Seuil, 1972) pp. 177-178.
16. Paul Gsell, "Chez Rodin," *L'Art et les artistes*, n° 23, February 1907, p. 396.
17. Unpublished manuscripts and rough notes, archives, Musée Rodin.
18. Handwritten notes by René Cheruy, Musée Rodin.
19. Valentine de Saint-Point, "La double personnalité de Rodin," *La Nouvelle Revue* November 1906, pp. 29-42.

Translated from the French by Sally Laurelle

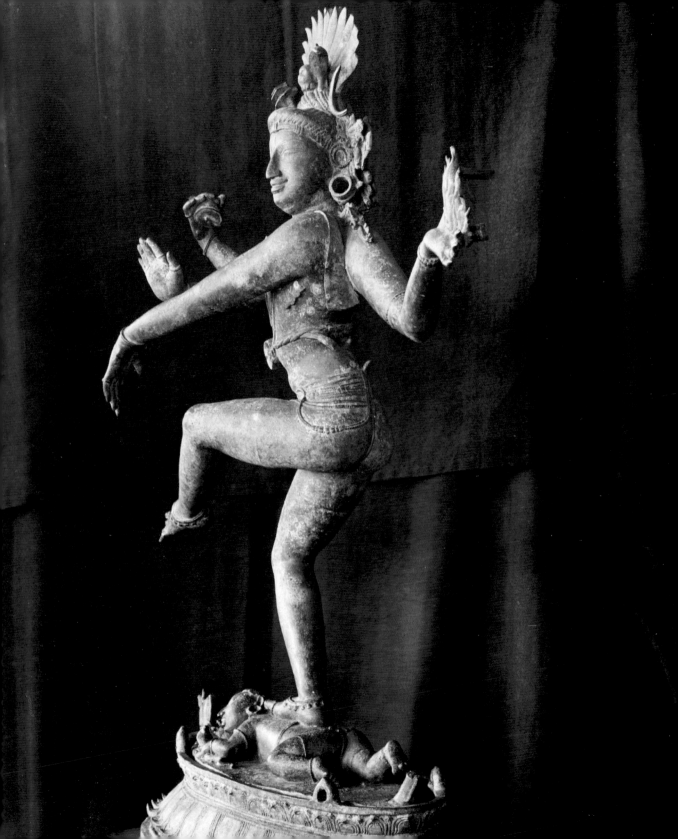

THROUGH EACH OTHER'S EYES: RODIN AND NATARAJA

H.S. SHIVAPRAKASH

1

Rodin's poetic response to the image of Nataraja is a communion across cultures, at once profound and transformative. It was a creative encounter. It was as if the image came to him *ex nihilo*. Perhaps he knew nothing about the mythology, theology and conventional symbolism surrounding the image. His encounter was, therefore, immediate and intensely sensuous. The dense prose in which he exploded rapturously speaks of this intensity. It is also a corroboration of how the power of image can speak across cultures, transcending barriers and existing interpretations, a view which W.B. Yeats, the Irish poet, expressed in his poem, "The Circus Animal's Desertion":

FACING PAGE: Photograph of one of the Shiva Nataraja bronzes, a recurrent source of artistic inspiration for Rodin

Colour and page took all my love,

And not the things they were emblems of[1]

2

To make sense out of Rodin's exuberant response, one needs to contrast it with that of learned scholars well-versed in history, sociology, mythology, theology, symbolism and complex metaphysics surrounding the image of the dancing god. Also, because the human creation of gods precedes interpretative exercises of the erudite, we should also contrast the former with the latter.

In this context, I am tempted to contrast with later theological interpretations, one of the earliest depictions of dancing Shiva, by the Tamil woman poet Karaikkal Ammaiyar (the woman saint of Karaikkal), dating back to 7th century CE. She begged Lord Shiva to rid her of exquisite beauty to avoid trouble from male suitors. Lord Shiva, we learn, granted her wish and bestowed on her a repulsive demonic form. Nicknamed *pay nayanaar (*demon woman-saint), she walked from shrine to shrine, worshipping and singing of Lord Shiva. Once she reached the cremation ground of a place called Tiruvalangadu (the forest of the sacred banyan tree), she had a vision of Shiva's joyous dance in the macabre environs of this deadly place, full of half-charred corpses, screeching owls, and shouting demons indulging in their hideous games.

Here are some snippets from Karaikkal Ammaiyar's two poems, both of which are called "Ten Verses on Tiruvanlangadu":

Rolling-eyed and flame-mouthed,

Dancing tunagakam, running about,

Ghouls lift up roasting corpses

And gobble them up. In such a place,

The jingling anklet bells!

He dances nattinai to their tunes,

His matted locks helter-skelter

That is my lord's home, Tiruvalankadu,

Seeing foxes grabbing rice grains

From fire-pits and eating,
Clapping their hands, ghouls scream:
'Foxes have got it. Why not we?'
A hullabaloo, running amok
In such ghastly places, he dances on,
His left foot up, touching the sky
That is my lord's home, Tiruvalankadu

This man who went from country to city
Hunting for joy is now dead
How he sleeps next to an aged man
Covered in a shroud. Still, setting
Woods and hills, lands and seas
Spinning, our lord dances.
Holding a torch in his raised hand,
That is my lord's home, Tiruvalankadu.

Is this corpse really dead?
Testing it with his finger, the ghoul
Gives a yell and throwing a firebrand
At it, starts to flee in terror;
So do other ghouls, beating
Their bellies with bewilderment
They too take to their frightened heels.
In such a fearsome wilderness
The Supreme One goes on dancing
Wearing the moon in his matted locks
He is dancing his spiral dance
The snake at the waist too is dancing
Whoever dances, through His Grace,
These ten verses sung by me,
Ghoul from Karai with mouth
Of fire and crooked teeth,
Will be rid of all sins.[2]

What is peculiar to Karai's intense poetic invocation is the sensuousness of it. It has no particular philosophy or mythology underpinning it, just the sensuous immediacy. Though it has several resemblances to the Chola bronzes that Rodin was responding to—the Nataraja in the *ananda tandava* position—it has marked differences. The crescent moon, the burning torch, the joyous abandon are points of resemblance. But Karai's Nataraja is performing another type of *tandava—urdhwa tandava*—raising his left foot straight up. Karai's Shiva, unlike in the bronze, is not alone; he is accompanied by the 'daughter of mountains'.

Despite a temporal gap of nearly 13 centuries between Karai-the-poet and Rodin-the-sculptor, there appears continuity between the two poetic invocations of the two artists also separated by a deep cultural gulf—a theme I want to return to a little later.

<div align="center">3</div>

The kinship between Shiva and dance goes back to 200 CE, the approximate period of the *Natyashastra*. Drama was invented by Brahma and dance by Shiva, says the *Natyashastra*. But the sculptural representation of Shiva's dance followed in the next three centuries. In Karnataka, the temples of Badami and Aihole show dancing Shivas of different forms, dating between the 5th and 7th centuries. In Tamil Nadu, Shiva's dance started assuming a definite shape in the 7th century. The Elephanta Caves near Mumbai, where stands a mutilated Nataraja, is also dated to the 5th century. Kailasnath Temple, which houses a magnificent Nataraja, came about in the 8th century.

It is argued that the Nataraja image attained its perfect form in Chola bronzes and sculptures after the 10th century. The Nataraja temple at Tillai became the acme of Tamil Shaivism as it is considered in the tradition to be the hub of Tamil Shaivite sacred geography. However, the glorification of Chola Natarajas or the Ananda Tandava Shiva *murthy* of Chidambaram Temple is contestable, as different Natarajas of different regions in Tamil Nadu, and other Natarajas of Karnataka, Maharashtra and Orissa differ in splendour, and depict different *lilas* of Shiva taken

from a cycle of myths related to him. The posture, the positioning of legs, the number of hands and weapons, the setting, the ornaments and moods vary from type to type.

The Nataraja theme was celebrated in other arts too: poetry, painting, dance and theatre.

The first poetic reference I know of Shiva's dance is the Tamil epic *Cilappadikaram*. In the third part of the poem, during the celebration of the Chera king's victory, a dancer performs the *ardhanarishwara* dance. But the most elaborate description is in Karai's poem quoted above. The poets of *Tevaram* also sang of Shiva's dance from different perspectives. One of the greatest texts of Tamil Shaivite canon—the *Tiruvacakam*—centred around the Chidambaram Temple.

Poets from other Indian languages have also joined the chorus of Tamil poets in singing of Shiva's dance. One of the most passionate dramatisations is found in Ravana's Sanskrit hymn *Shiva Tandava Stotram*. Shaivite poets of Karnataka also sang of Nataraja's cosmic dance. The most evocative of them is a poem by the thirteenth-century Kannada poet, Harihara, in which Shiva performs his *urdhwa tandava* (one feet trampling the earth, the other, touching the sky), not in any temple, but in the humble workplace of a potter Gundayya. Rabindranath Tagore also has a remarkable poem on the *tandava* dance of Shiva: "Forgetting his own self, he performs his dance of destruction, Nataraja with matted locks."[3]

Over the centuries, across languages and artistic genres, there are many Natarajas dancing widely different variations of *lasya* and *tandava*.

None of this was known to Rodin.

4

Stella Kramrisch identifies Shiva with human consciousness, as did monistic Shaivite schools of Kashmir. Nataraja is the dynamic aspect (*unmesha*) of it, whereas Shivalingam is the static form (*nimesha*). The dynamic aspect, too, has, as we have seen above, diverse manifestations and representations. However, the dance form which got the highest circulation is the *ananda tandava* of Chidambaram.

The Tamil Shaivite theologians developed an elaborate mythology and esoteric satoriology based on it. The different body parts of dancing Shiva became symbolic of five different cosmic functions of Shiva; of five letters of *panchakshara* mantra—OM NAMA SHIVAYA; of five elements of the cosmos, and so on. It is this image that is the basis of Ananda Coomaraswamy's celebrated interpretation in *The Dance of Shiva*[4], though he does briefly mention *pradosha tandava* and *bhairava tandava*. It is this image again that inspired the famous composition by Gopinatha Bharathi, a top-favourite with Bharatanatyam dancers. It is the same form that, thanks to Fritjof Capra's elevation of it into a scientific metaphor, now adorns the building of CERN in Switzerland as a symbol that unifies east and west, science and spirituality.

Coomaraswamy has been critiqued on various grounds for valourising this particular representation: for his ahistoric approach, overdependence on textual materials at the expense of ignoring other mediums of representation, and an overall Orientalist position. I myself find even his Tamil literary references lacking as he makes no mention of Karai's significant poems on the theme.

Why did the Chidambaram Nataraja become so important?

Again, scholars argue that the reason is not the power of the image but that of Chola royal power that used it as a symbol of power. Even if this is true, what power did it have on Capra? Like good stories, good images draw people across cultures. Because we love them, we put our own meanings into them.

Still, the beauty and nuances of Nataraja cannot be limited to this one manifestation. The meanings we have been attributing to Nataraja could have become more varied and richer, had other manifestations been reflected upon with the same involvement.

Another question that comes up then: what is common to all Nataraja forms?

More than any sectarian theologian or ideology-bound scholar and like poets and artists who created and not interpreted Nataraja, I think Rodin came closest to answering the above question.

5

> In the full flower of life, the flow of living, the air, the sun, the sense of being is a rushing torrent. Thus appears the art of the Far East to us![5]

The above lines, opening Rodin's response, no doubt smacks of Orientalism in its overenthusiasm to characterise the art of the Far East in an ahistoricist way. But what follows is not an extension of this preamble, but a departure from it. He plunges us into a torrent of images. During the course of his poetic meditation, he notes, "Words do not suffice..." So he transmutes words into sensory percepts, as if they are fingers to touch and feel with.

Though inhabiting the same milieu and epoch of his Orientalist contemporaries who turned Indian images into "much maligned monsters", he confronts an image from the east with these words:

> The ignorant man simplifies and sees crudely; he draws back from superior art in order to love the inferior; he realizes nothing. One must study more deeply to be interested, and to see...[6]

Not for him, the habit of seeing Far Eastern art as "barbarous". No wonder he likens the image to that of Venus de Medici, though the sensuous abandon of Nataraja contrasts with Aphrodite's conspicuous coyness. With word-fingers he touches every part of the image and re-creates the experience in haunting poetic word-images. For instance:

> These lips, like a pleasure lake bordered by noble, thrilling nostrils. The mouth undulates in moist pleasure, sinuous as a snake; the eyes are closed, swollen, closed amidst a drapery of lashes. The wings of the nose, delicately drawn against the fullness of the face.[7]

While feeling different body parts, he also senses its hidden unity:

In sum, it is the virtues of depth, of opposition, of lightness, of power, that matter here—but none of them are worth anything alone; they are useless embellishments except in relation to movement...[8]

If one can at all sum up his dense prose, what his word-fingers and images are invoking are the ways in which matter errupts into a sculpted body of perfection, shot through with an intense desire to be born into a new life of movement where restraint and abandon coalsce.

Unlike interpreters of different hues, Rodin sees in the details, images not concepts or pre-given meanings outside the purview of an immediate encounter, but creative forms in the making.

Unlike devotees who see in them a reminder of another reality, he extracts other, more immediate, realities from the transformation of the materiality of bronze.

It is in this sensuous immediacy of response that he comes close to the equally sensuous evocation of Shiva's dance in a poem by Karai, whom he had never known. Both their evocations have an elemental and primordial grasp, which, though happening in time and place, escape their clutches.

6

Just as aesthetic images can be turned into commodities by agents of different power strucures, religious and political, the reverse process of turning them into pure aesthetic objects also happens in human encounters as it did in the case of Rodin's experience of Nataraja. Such pure encounters, not necessarily informed by objective scholarship, happen; new avenues open in creativity. This happened, for instance, when during different epochs artists encountered materials from other cultures. This happens ouside history, though in history. To deny this is to reduce all art exchanges to slaves of time and history.

How the discovery of the Nataraja bronze impacted Rodin's own creativty also needs a deep study to comprehend the full creative import of his discovery—an area which I, not being a Rodin scholar, dare not enter into.

Let me conclude my response to Rodin's response to Nataraja with a poem of mine inspired by that response:

Aeons and aeons of stillness is at an end:
From silence's womb, listen! *Damaru*-beats!
Time-trodden, wakes up the human body,
Shamed into inertia by death-deliverers,
Who had shackled even the soul, the born dancer.
In renewed cosmic spring are born
The dancer and the dance to trample down
And invert long history of immobility
The hands that covered the shameful organs
Now open wide in joy and pride to embrace
The infinitude of all-pervading space.
So do the three eyes to gather everyone
Of immeasurable world's undulating joys
Like the flaming tongues of a million-
Hooded serpent, the fiery strands of
Matted locks spread out in all directions;
As do the sun- and moon-beams from
The two glowing eyes while the flaming
Fountain in the third eye is setting ablaze
Everything blind, deaf and dumb, Dance
Now O All-annihilator! O dancing feet!
O bodied torch! O swaying torso! O *damaru!*
All of you illuminated softly by a crescent
Where all pasts and futures are present.[9]

Endnotes

1. W.B., Yeats "The Circus Animal's Desertion". Text of the poem available at |<http://ireland.wlu.edu/landscape/Group5/poem.htm> Last accessed on: 15/01/2013.
2. Translated by author from the original text. *Hymns of Karaikkal Ammayar* (Dharmapuram, Mayiladuthurai: IISSR, 1993).

3. Rabindranath Tagore, "Pralay nachan nachle jakhan he Nataraj/ Jatar badhan porlo khulo...," a song from the drama *Tapati*. Translation by author from song sung by Swagatalakshmi Dasgupta available at <http://www.youtube.com/watch?v=CLgzkXMxEAs>. Last accessed on: 15/01/2013.

4. Ananda K. Coomaraswamy, *The Dance of Shiva* (New Delhi: Sagar, 1987).

5. Auguste Rodin, "The Dance of Shiva," in *Venus*. Hol Art Books: Barnes and Noble (e-book), 2009. The entire text of 'The Dance of Shiva' is available at <http://poetryinstone.in/lang/en/2010/02/22/the-dance-of-shiva-a-study-on-the-tiruvalangadu-nataraja-at-madras-museum-by-aguste-rodin.html>. Last accessed on: 15/01/2013.

6. Ibid.

7. Ibid.

8. Ibid.

9. H.S. Shivaprakash, "Nataraja," in *Matu Mantra Vaguvavarege* (Aharnishi Prakashana: Shimoga, 2012).

CONTRIBUTOR'S BIO

Bénédicte Garnier

Bénédicte Garnier is the scientific incharge of the Rodin antique collection and the Meudon site of the Musée Rodin. In 2000 she has defended a Doctorate thesis at the University of Paris IV – Sorbonne titled "Circle of Antiques" and dedicated it to the history of collection of antiques of Auguste Rodin. She has curated for the Rodin Museum the exhibition called "Passion at Work, Rodin and Freud collectionneurs" in 2008. And also an exhibition sub-titled "Rodin – A Japanese Dream" in 2007. Jointly published with Musée Rodin, her book *Rodin: antiquity is my youth: a sculptor's collection* appeared in Paris in 2002.

H.S. Shivaprakash

Hulkuntenmath Shivamurti Sastri Shivaprakash was the director of Tagore Centre at Berlin, and is a professor at the school of Arts and Aesthetics at the Jawaharlal Nehru University, New Delhi. He is both a poet and dramatist in Kannada and English. Amongst his publications are about thirty collections of poems and theatrical pieces. His works have been translated into English, French, Italian, Spanish and German and into many Indian languages. In India Shivapakash is considered one of the greatest specialists of "Vachana" literature connected to the mystic and devotional movement of South India. Since 2000 he is honorary member of the Art School of the University of Iowa. In 2012 he received the Sahitya Akademi prize for his work *Incredible India: Traditional Theatres*.

PHOTO CREDITS

INDEX